ISABELLA STEWART GARDNER MUSEUM

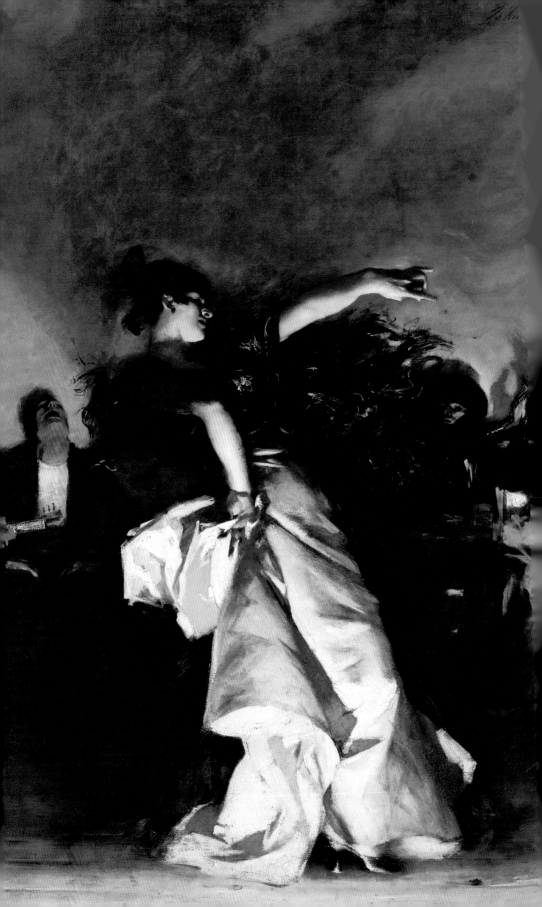

ISABELLA STEWART GARDNER MUSEUM

A GUIDE

Christina Nielsen
With Casey Riley and
Nathaniel Silver

Isabella Stewart Gardner Museum, Boston
Yale University Press, New Haven and London

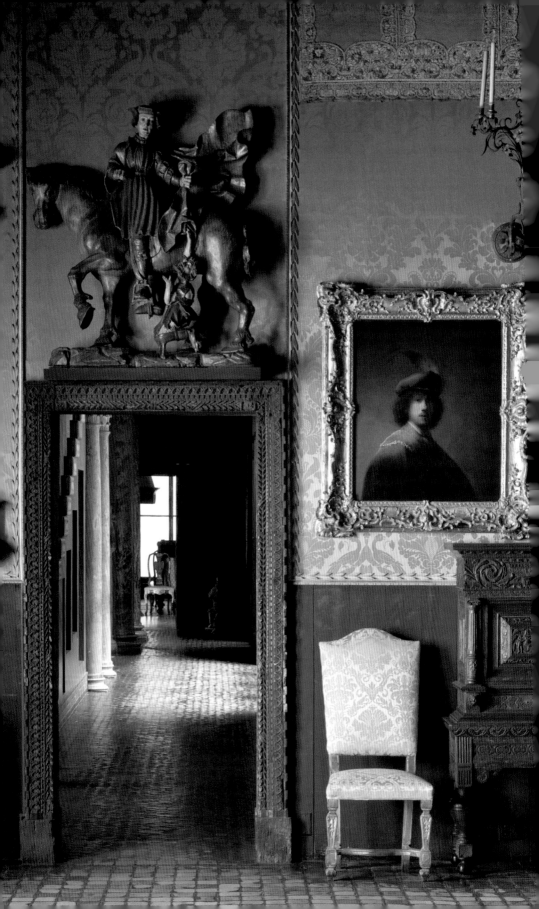

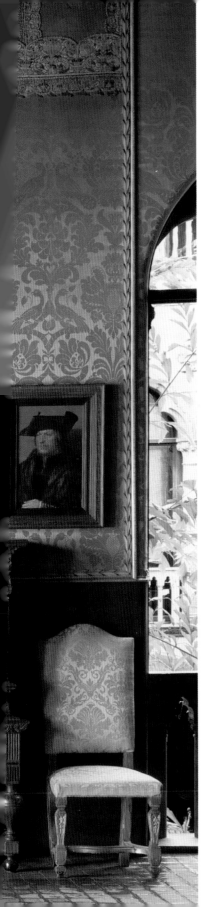

CONTENTS

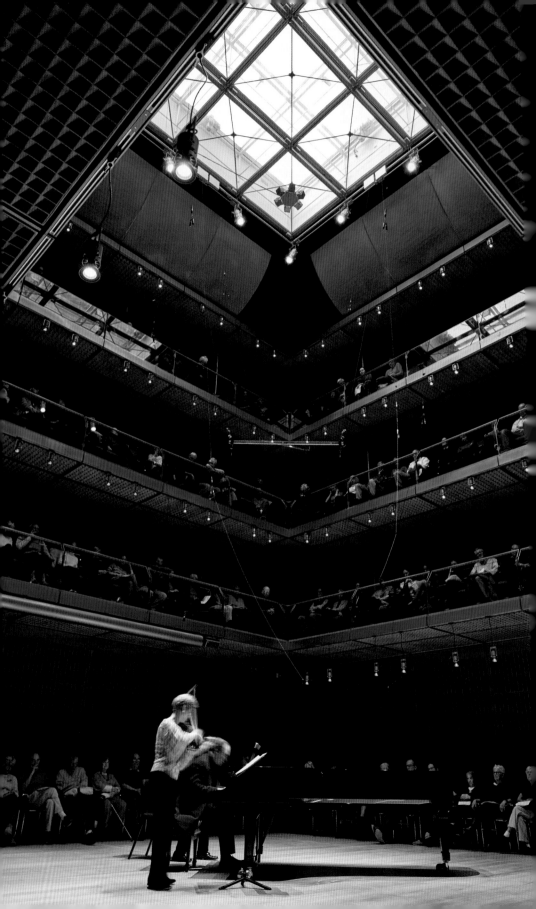

DIRECTOR'S FOREWORD

Visitors to the Isabella Stewart Gardner Museum often remark on the intimate and highly personal nature of the museum's historic galleries, which everywhere reveal Isabella's own bold, quirky, yet exquisite arrangement of art objects from various cultures and periods of history. Despite the pervasive sense of a personalized home that the galleries exude—Gardner in fact lived on the fourth floor of her palace—they were designed for a public purpose. Beginning in the late 1800s, Gardner set out on a mission to provide the American public with access to an experience of beauty through art; she formed her exceptional collection and conceived of the building to house it in order to address what she considered the greatest need of a new nation. As she wrote to her friend Edmund Hill in 1917, "We were a very young country and had very few opportunities of seeing beautiful things, works of art etc. So I determined to make it my life [*sic*] work if I could."

Since the museum opened in 1903, millions of visitors have cherished the collection and its evocative setting. The experience of strolling through Gardner's galleries accompanied by the sound of trickling water and the scent of blooming greenery wafting from the central courtyard, and finding personal meaning in the juxtapositions of fine art and decorative objects ranging from antiquity through the twentieth century, is unlike a visit to any other American museum. When Gardner died in 1924, she bequeathed her museum "for the education and enjoyment of the public forever," as stated in her will, and we continue to strive to realize that ambition for all visitors, near and far.

Since the last guidebook was published in 1995, the museum has undergone extraordinary transformations. Most immediately visible is the addition of a new building designed by renowned architect Renzo Piano; this New Wing, full of light and transparency, extends a warm welcome and provides a platform for dynamic programs, such as special exhibitions and performances. Nonetheless, Gardner's historic palace remains the heart of the museum and continues to manifest her belief—and ours—that art is a vital component of civic life and opens pathways for understanding ourselves and each other in relation to the world around us.

This guidebook offers an invitation to explore the collection and the many stories told by the individual works of art, as well by as Gardner's multilayered display. Most important, it is also an invitation to make personal discoveries and find meaning. We hope you will enthusiastically agree, as Gardner herself proposed over one hundred years ago, that art and beauty are as necessary now as ever, if not even more so.

Peggy Fogelman
Norma Jean Calderwood Director

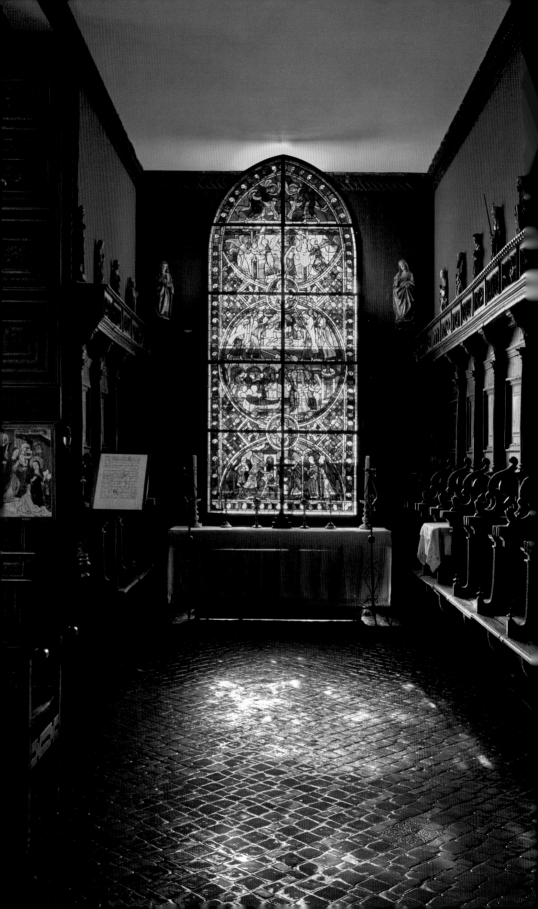

ACKNOWLEDGMENTS

As with everything at the Gardner, this book reflects the collaborative effort of numerous individuals. My coauthors Nathaniel Silver, Associate Curator at the Gardner, and Casey Riley, now Assistant Curator at the Boston Athenaeum, and I benefited enormously from the tremendous support of Peggy Fogelman, the Norma Jean Calderwood Director at the Gardner; the tireless patience and enthusiasm of Elizabeth Reluga, Collections Administrator, the project manager for this guidebook; and the generosity of Peggy Burchenal, Esther Stiles Eastman Curator of Education, who gave so much time and thought to the concluding Legacy section. Other Gardner staff who contributed in myriad ways include Jennifer Yee, Associate Director of Security Operations; Anthony Amore, Director of Security; Lauren Budding, Director of Institutional Advancement; Mary Ellen Ringo, Manager of Corporate and Institutional Support; Tiffany York, Residency and Contemporary Program Manager; Pieranna Cavalchini, Tom and Lisa Blumenthal Curator of Contemporary Art; Grace Coburn, Greenhouse Assistant; Stan Kozak, Chief Horticulturalist; David Mathews, Collection Photographer; Matthew Del Grosso, David Kalan, and Ann Walt Stallings in Registration; Amanda Venezia, Head Registrar for Collections and Exhibitions; Shana McKenna, Archivist; Victor Oliviera, Director of Retail; Carolyn Royston, Director of Digital and Information Services; Gianfranco Pocobene, John L. and Susan K. Gardner Chief Conservator; Holly Salmon, Senior Objects Conservator; Sarah Towers, Objects and Paintings Conservation Technician; and Kathy Sharpless, Director of Marketing and Communications. Anne Hawley, former Norma Jean Calderwood Director, supported this book from the beginning and shared her ideas and passion. We are also extremely grateful to others outside the Gardner who have helped us realize this project: Fronia Simpson, copy editor; Amy Canonico, Associate Editor, Art & Architecture, at Yale University Press; Alan Baglia, Rights Administrator at ARS; Carolyn Cruthirds, Coordinator of Image Licensing at the Museum of Fine Arts, Boston; and Christopher Richards, former Collections Cataloguer. Photographer Sean Dungan helped us see the extraordinary beauty of the museum through a new lens.

Christina Nielsen
William and Lia Poorvu Curator of the Collection and Exhibition Program

ISABELLA STEWART GARDNER

The invitations to the gala opening of the museum in 1903 were characteristically direct: "Mrs. John Lowell Gardner requests the pleasure of _____'s company on Thursday evening, January 1st, at nine o'clock punctually. Music. Fenway Court. R.s.v.p."

On the appointed night, carriages bearing several hundred of Boston's most prominent citizens traversed frosty streets to a sandy-brick building at the edge of the Back Bay Fens. By Isabella Stewart Gardner's design, few had glimpsed the interior of the four-story edifice that she called Fenway Court, and the precise installation of her extraordinary collection of art from Africa, Asia, Europe, and the Americas had drawn the speculation and fascination of the press for the better part of the past three years. The elegant company that stepped down from their carriages therefore had little idea of what had been arranged for their pleasure behind those deceptively unadorned walls facing the Muddy River.

The impresario of the evening greeted her guests on the landing of a curving white horseshoe staircase in the museum's Music Room. She cut a slight figure, swathed in black and belted tightly at the waist, the diamonds of her aigrette dancing on springs that rose from her hair. When the lights went down, the conductor Wilhelm Gericke led fifty members of the Boston Symphony Orchestra in a program that included a chorale by Bach, the overture

Adolph de Meyer, Isabella Stewart Gardner, 1906

Thomas E. Marr and Son, Isabella Stewart Gardner Museum, 1903

from Mozart's *Magic Flute*, a symphonic poem titled "Viviane" by Chausson, and Schumann's Overture, Scherzo, and Finale. A reviewer from the Boston *Transcript* wrote the next day that the acoustics in the hall were "matchless."

When the music ended and the applause receded, a signal was given, and, in the words of Gardner's biographer Morris Carter, "a great mirror in one corner of the hall was rolled back and the guests were admitted to the court. No one was in the least prepared for the fairy beauty that greeted his eyes. . . . Here, in the very midst of winter, was 'a gorgeous vista of blossoming summer gardens . . . with the odor of flowers stealing toward one as though wafted on a southern breeze.'" Beyond the enchanted looking glass, the guests encountered a courtyard lush with carefully tended greenery and lit by the orbs of hanging Japanese lanterns, the pink stucco walls reaching up four stories to a vaulted glass ceiling that framed the stars. Guests wandered a museum sparkling with treasures whose gilded frames caught the light of each glowing fireplace.

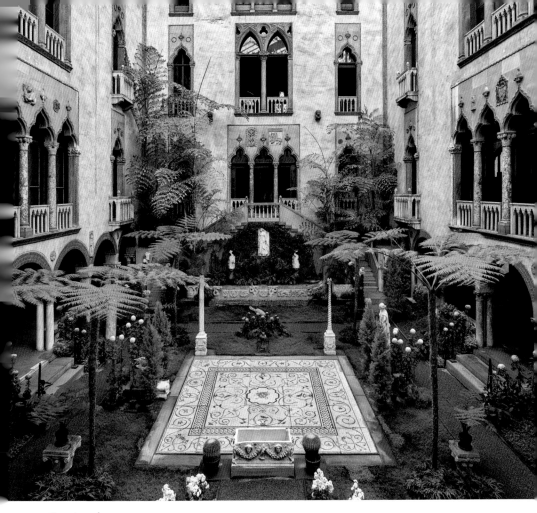

Courtyard

That these objects had been amassed and arranged so effectively by their host seemed miraculous. In the following days, these first guests of the museum would describe the experience as something close to transcendence, each room an assemblage and a masterwork in its own right. It was, as Carter later wrote, a triumph.

With this spectacular opening, Isabella Stewart Gardner initiated her tenure at the helm of an extraordinary American institution. Whereas opening night was dedicated to her friends, the following "open days" for the museum were for the public: anyone who could afford the one-dollar ticket could gain entrance to her museum. In the weeks and years to come, students, teachers, artists, writers, and all manner of people would be welcomed at the museum. It was the culmination of years of labor, and it was her pleasure to share it after years of travel, reading, study, and conversation with some of the brightest minds of her era.

Isabella Stewart was born to Adelia and David Stewart in New York City on April 14, 1840. Although her parents had achieved worldly success by the time of her birth, they came from relatively modest backgrounds. Her mother was the daughter of Selah Smith, a Brooklyn tavern keeper and stable owner. Her father, who had been raised by his widowed mother on a farm on Long Island, built a prosperous career as an importer of linen and other goods from Scotland and Ireland throughout his early life and later made his fortune in the mining industry. The family lived for much of Isabella's youth at a house on University Place in downtown Manhattan; they attended Grace Church. The elder Stewarts would have three more children in the years after Isabella's birth—Adelia in 1842, David in 1848, and James in 1858—but none enjoyed the longevity of their eldest sister: Adelia died at the age of twelve, David when he was twenty-six, and James when he was twenty-three. Perhaps because of these early losses, Isabella was reticent about her childhood and upbringing. Despite her reserve, she enjoyed sharing stories of her paternal grandmother, the indomitable Isabella Stewart. The younger Isabella loved and admired her grandmother, who was a prizewinning horticulturist, and on visits to the farm rejoiced in the freedom and fresh air it afforded. Many years later, Isabella Stewart Gardner placed a garden at the center of her museum and paid tribute to her beloved grandmother by displaying, in a case in the Short Gallery, an engraved silver pitcher that had been presented to her grandmother by the Agricultural Society of New York in 1821.

When Isabella was sixteen, she traveled to Paris with her parents and entered finishing school, where she met Julia and Eliza Gardner of Boston. The Gardner and Stewart families enjoyed a comfortable rapport, and the connection forged in Paris lasted after the Stewarts continued to Italy in 1857. While in Rome, Isabella studied Italian with another new friend from Boston, Ida Agassiz, who later married the Boston Symphony Orchestra founder Henry Higginson. Ida recalled many years later that Isabella had told her even then that she planned to have a house "filled with beautiful pictures and objects of art, for people to come and enjoy." The Stewart family returned to the United States in 1858, and in 1859 Isabella visited the Gardners at their home in Boston. Julia and Eliza's brother John "Jack" Lowell Gardner fell head over heels for Isabella during that stay, and the two were married in April 1860. Kind, sensible Jack was a steady complement to Isabella, with her electric personality and charisma, and the two forged a bond that would last through many challenges in the years to come.

The early years of marriage were difficult for Isabella, who was often bedridden with an unspecified illness. Life brightened considerably after she

Miniature portraits of John "Jackie" Lowell Gardner III, Isabella Stewart Gardner, Joseph Peabody Gardner, Jr., and John Lowell Gardner, Jr.

and Jack moved into the home they built at 152 Beacon Street and welcomed their only child, John L. Gardner III, "Jackie," in June 1863. Isabella and Jack adored their blue-eyed little boy, but their joy was short-lived: Jackie was seized with pneumonia and died in the early spring of 1865, leaving his parents devastated. Decades later, she placed a miniature portrait of her child in a velvet-lined case above smaller photographic portraits of herself and Jack and put the case inside a vitrine in her museum's Little Salon—a nearly invisible yet deeply poignant homage to her brief years of motherhood.

For two years after Jackie's death, Isabella was immobilized by an intractable depression. Heeding the advice of the family physician, she and Jack embarked on a journey to northern Europe and Russia in 1867, where she found a renewed sense of purpose. The distinctive streets and architecture of Copenhagen, Stockholm, St. Petersburg, and Vienna, as well as the dramatic fjords of

Norway, inspired her to collect souvenir photographs and arrange them in an album, a practice that would become central to her travels in the decades to come. Midway through this journey, she recovered enough of her playful spirit to pose in traditional Norwegian costume for a series of photographs, smiling shyly for the photographer in each print. When she returned to Boston in 1868, it was with a mind refreshed by exposure to the arts, culture, and people of other nations, her curiosity piqued by the feelings of discovery that had lain dormant since her teenage years in France and Italy.

In the years after this journey, Isabella planned many other adventures abroad. An avid reader of every imaginable genre, she planned her trips with a literary frame of mind, seeking the landscapes and people she had encountered on the printed page. In turn, between 1874 and 1895 she created twenty-eight travel albums that were illustrated with photographs collected along the way, visual narratives of her experiences across the globe. In 1874 and 1875 she and Jack traveled along the Nile, where she kept a stunning diary illustrated with photographs as well as her own watercolor sketches; they would go on to hike the Holy Land together and to see the sights in both Constantinople and Athens before returning to western Europe. References to *The Arabian Nights* and the Holy Bible are scattered throughout her albums and diaries from this journey, revealing the connections she imagined between the sites she visited and the stories she had read since childhood.

Toward the end of their journey, Jack and Isabella received word that Jack's widowed brother had passed away, leaving his three school-aged boys—Joseph, William Amory, and Augustus—orphans in Boston. When she and Jack returned to the States in 1875, they brought their nephews into their home and raised them as their own. Isabella devoted significant time to their upbringing and took the boys' education seriously; she often read to the boys and especially enjoyed reading Charles Dickens's novels to them on the weekends. Many years later, she placed letters signed by Dickens in a case in the Long Gallery of her museum as a remembrance of those happy family years.

In 1879 Isabella and Jack took the youngest two boys on a tour of England and France. Among Isabella's dinner companions in London was the author Henry James, who encouraged her to attend an opening at the Grosvenor Gallery in July 1879, at which Isabella first viewed the work of James McNeill Whistler. Isabella's friendship with Henry James was vital to her later patronage of contemporary art, as he provided introductions not only to Whistler but also to John Singer Sargent on a subsequent journey in 1886. The 1870s were therefore a time of familial enrichment as well as expansive cultural and aesthetic engagement.

Isabella Stewart Gardner, *Travel Album of Great Britain and France: Versailles,* 1879

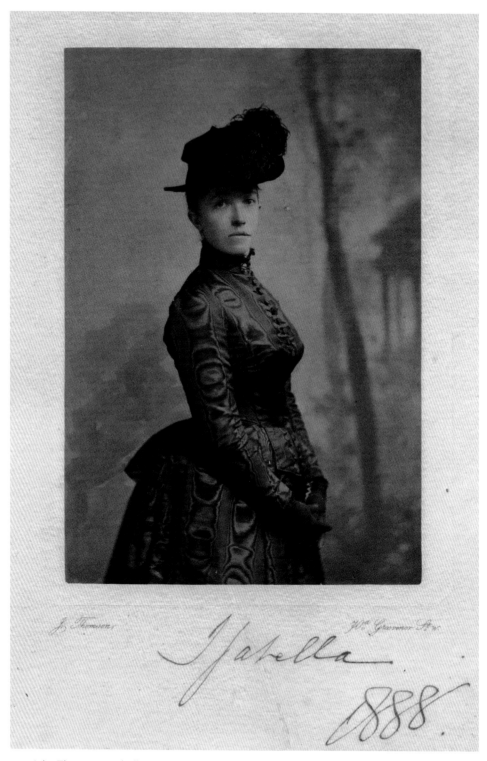

John Thomson, Isabella Stewart Gardner, 1888

BUILDING INTERNATIONAL NETWORKS

In the late 1870s and 1880s Isabella devoted increasing energy to her intellectual development. Perhaps inspired by her nephews' example, she attended the lectures of Charles Eliot Norton, the first professor of fine arts at Harvard University, in the spring of 1878; by 1885 she was a regular attendee at the readings of Dante at Norton's home in Cambridge. She joined the Dante Society in 1886 and subsequently collected a number of important early print editions and one manuscript of the poet's work for her burgeoning collection of rare books and manuscripts. These books would form a key part of her museum's exhibitions and inspire her support of literary figures of her time. Isabella catalogued her books and manuscripts and published descriptions of them in 1906 and 1922, making a record of her collection available to scholars and connoisseurs.

The literary and artistic traditions of cultures beyond the Western Hemisphere were of great interest to Isabella from the 1880s until the end of her life. Boston was home to many people who were eager to expand their knowledge of Asia, and in 1882 Isabella and Jack Gardner hosted a private series of lectures on Japan by Edward Sylvester Morse at their Beacon Street home. Isabella was apparently captivated by what she learned of spiritual and aesthetic life in Japan and began planning a journey through Asia. In 1883 and 1884 Isabella and Jack traveled extensively throughout Japan, China, Cambodia, Singapore, Java, Burma, and India, where they relied on their extended circle of friends and acquaintances to navigate each place. Isabella was intrepid in her journeys, traveling to such major cities as Tokyo, Beijing, and Jaipur but also to more remote sites, such as Angkor Wat. She sought out all manner of teachers, meeting with the scholar of Japanese art Ernest Fenollosa and trying to do the same with the famed mystic Madame Blavatsky, whose glowering photographic portrait appears in Isabella's travel album. Her tastes guided by an open-minded and ecumenical approach to cultural offerings both high and low, Isabella sought sensation as well as authenticity, spectacle, and serenity in her travels throughout Asia.

The Gardners returned to Europe in 1884, choosing Venice as their destination. Isabella immersed herself in the art and architecture of the lagoon city, its historic waterways providing her passage to the works of artists who would later fill her museum: Bellini, Carpaccio, Guardi, Mantegna, Titian, and Veronese, among many others whose paintings she viewed at the Accademia and in historic churches. She would return to Venice for many seasons, having identified a home for the cultivation of her unconventional intellect away from the demands of social life in Boston. While the Gardners stayed in hotels their first few seasons in Venice, in 1890 they began to rent a floor of a historic home,

Isabella and Jack Gardner with Emma and Anders Zorn, Venice, 1894

the Palazzo Barbaro, and gathered friends and family there for several more seasons. Though Isabella continued to travel in the decades leading up to the opening of the museum, Venice became an important nexus in the ever-expanding map of her social networks and a site that allowed her to nurture a future vision of herself as a cultural maker and leader.

Isabella's friendships in Venice were formative for her activities as a patron of arts and letters. She also found the company of artists who would become trusted advisers as well as contributors to her collection, including Joseph Lindon Smith and Ralph Curtis. She hosted dinner parties that included an international array of talent: Violet Paget (whose pen name was Vernon Lee), Anders Zorn, Henry James, John Singer Sargent, Antonio Mancini, and many others. Visiting nearly every other year from 1884 until 1899, and then once more in 1906, Isabella immersed herself in the city's glamorous swirl of artists, writers, and musicians.

THE MUSEUM IN HER TIME, 1903–24

In 1891, David Stewart died and bequeathed $1.75 million to his daughter, Isabella Stewart Gardner. As her biographer Morris Carter stated, "Mrs. Gardner now settled down definitely to the business of collecting works of art." She relied on a number of advisers in the ensuing decade of purchases and began by soliciting help from her friend Ralph Curtis, an artist and a member of the Boston-based expatriate family who owned the Palazzo Barbaro. He acted as her agent in acquiring a set of gilt and painted armchairs from the Borghese collection and accompanied her to a viewing of Vermeers from the Thoré-Bürger collection in Paris in December 1892, where she selected one—*The Concert*—as her mark in the upcoming auction. Her tactics in securing this painting would become the stuff of legend: using the art agent Fernand Robert as her proxy while she sat across the auction floor, Isabella instructed her representative to continue bidding as long as she held a handkerchief to her cheek. She got the picture, learning afterward that representatives from the Musée du Louvre in Paris and the National Gallery in London had both wanted the painting. Their consternation over her success only heightened Isabella's feelings of triumph— a sentiment that continued in the years to follow as she added to her collection.

Isabella's relationship with the art historian and connoisseur Bernard Berenson was vital to the growth of her collection in the 1890s. Berenson understood the psychology of the collector and stoked her appetite with tantalizing offerings—"How much do you want a Botticelli?" he asks in his initial offering regarding *The Tragedy of Lucretia*, a work that now hangs in her museum's Raphael Room. She wrote back to him in disarmingly candid terms, observing, "I suppose the picture-habit (which I seem to have) is as bad as the morphine or whiskey one—and it does cost." Their work together yielded many successes, including some of the works considered central to the collection, most notably Titian's *Rape of Europa*, a work that she was "breathless" over after it entered her possession in 1896.

By then she and Berenson wrote regularly to one another about the public collection that would result from her efforts. "Shan't you and I have fun with my museum?" she exclaimed in one letter. Yet while it was a great pleasure to build a collection, it was also something that she viewed as a form of responsibility to the nation. As she put it to Berenson in 1896—the year in which so many of her masterpieces were secured—"Don't you agree with me that my Museum ought to have only a few [masterpieces], and all of them A. No 1.s.... Let us aim awfully high. If you don't aim, you can't get there."

By the summer of 1897 Isabella had secured most of the cornerstones of her collection and begun to amass the architectural fragments that would become integral to the building. Traveling with Jack throughout Europe well

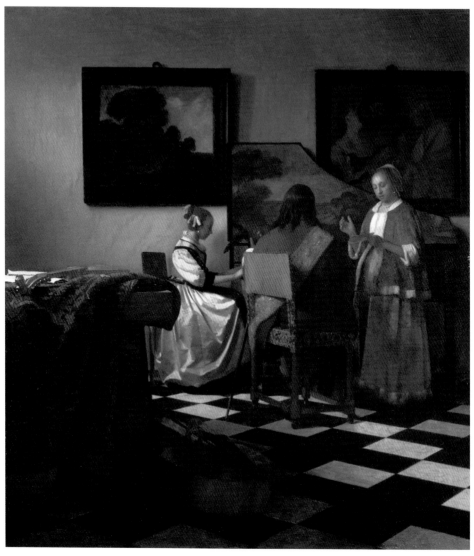

Johannes Vermeer, *The Concert*, 1663–66

into the fall, she purchased columns, windows, and doorways to adorn every floor of the museum. By the end of the following year she had added works by Rembrandt, Raphael, Rubens, and Cellini to her impressive collection and solicited the advice of her attorney, Henry Swift, in the formation of her "museum idea." Sadly, Jack did not live to see that project to fruition: he died of a stroke in December 1898. Yet the two had shared the details of her plans for so many years that Isabella chose to mourn her losses privately and to forge ahead with the project in early 1899.

On January 31, 1899, Isabella purchased the land on which the museum now stands, and in June the pile-driving began for the foundation of the

building. By December 1900 she had formed the corporation that would over-see the uses of her collection, which was "formed for the purpose of art educa-tion, especially by the public exhibition of works of art," thereby signaling the goals of her collecting practices to the public.

Throughout 1899 and 1900 Isabella presided over the construction site for her museum. Her interest was acute, and her opinions were strong. During the building process she used her box camera to take snapshots of the building rising from the Fens, climbing the rickety scaffolding in her ankle-length skirts to stand at the roofline and photograph the city in the distance. Isabella prided herself on her daily presence on the job site and took a hands-on approach to the work. Photographs reveal her standing on a ladder placed in the courtyard, demonstrating to the plasterers and painters the precise effects that she sought in layering the distinctive pink, white, and gray elements of the mottled stucco walls. When the ceiling beams arrived for the Gothic Room and appeared to be too smooth for her liking, she took an ax in hand and hacked away at the logs to achieve the desired result.

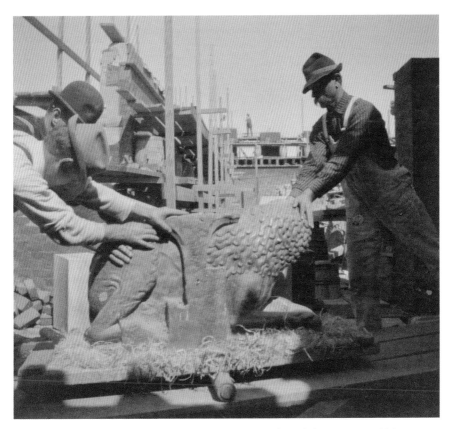

Workers moving a stylobate lion during the construction of the museum, 1900

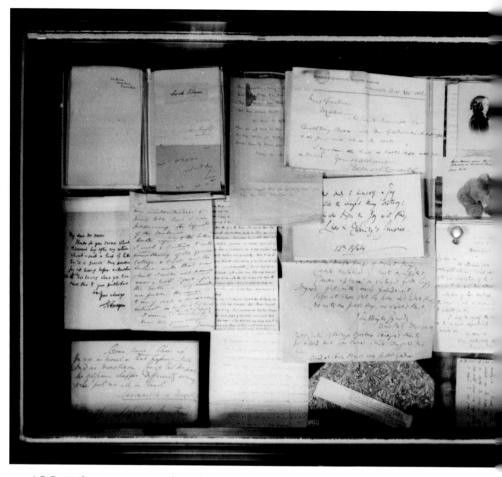

J. B. Pratt, Contemporary Authors Case, Long Gallery

By the end of 1901 Isabella had moved into her private apartment at the top of the museum. She spent much of the following year arranging the furniture, textiles, books, decorative art objects, sculpture, and paintings. As the museum took shape, Isabella worked on her plan for the installation of each gallery. While she noted the location of a few works on the blueprints for the museum, scrawling the name "Rembrandt" in a key location in the future Dutch Room, she left few other traces of her strategies for arranging the displays. In 1902 and 1903 she installed one of the most distinctive features of her curatorial agenda: fifteen waist-high glass cases that contained personal correspondence, collected letters, and photographic portraits, as well as a range of ephemera. The cases allowed Isabella to display her social and professional networks, integrating the work of these relationships within the broader scheme of her collection. Through the cases she claimed a definitive place for herself among the pantheon of statesmen, artists, authors, scientists,

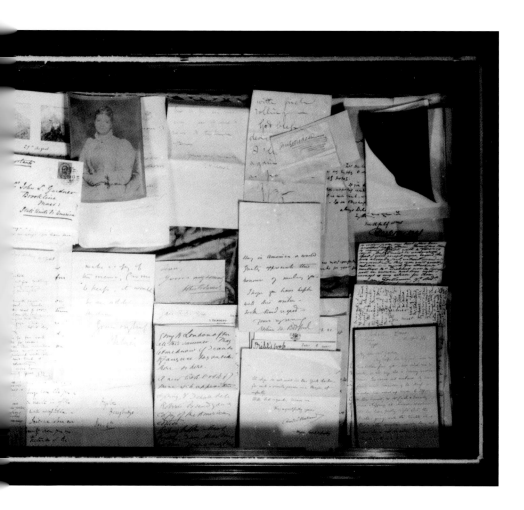

historians, poets, actors, and others who inspired the nation at the turn of the twentieth century.

When the museum opened to the public in February 1903, visitors thronged to see its treasures. Isabella commissioned undergraduate students from Harvard College to serve as guards on open days. Tickets were sold daily in limited batches of two hundred or three hundred at Herrick's Ticket Office in Copley Square, and visitors were allowed to walk through designated areas of the museum in a predetermined path. Retracing one's steps was strictly prohibited, and both the Chapel and the Gothic Room on the museum's third floor were off limits to the public. Still, visitors were astonished by the scope of what they saw, and those within Isabella's private circle of friends were just as moved. Her friend Sarah Wyman Whitman, who designed the distinctive crest bearing a phoenix rising from the ashes and the phrase *C'est Mon Plaisir* (It Is My Pleasure) above the museum's central entryway, claimed that Isabella's

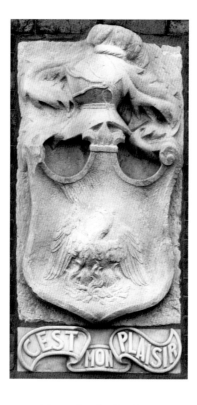

Designed by Sarah Wyman Whitman, *Crest of the Isabella Stewart Gardner Museum*, about 1900

arrangement of boxes on a table in the Gothic Room once moved her to tears, so complete was its perfection.

Although none of the galleries featured labels or explanatory texts as part of the overall installation, Isabella wrote and published several catalogues of the collection. Her museum guide provided an overview of the major works in each gallery, following a course through the museum from the first-floor galleries to those on the third floor. Visitors could also purchase photographs of the building and the collection taken by the firm Thomas E. Marr and Son, which documented the museum throughout her lifetime. These souvenirs were treasured by guests as well as museums, libraries, and universities across the United States, which sought images of the matchless collection for their own patrons and students.

The museum was not only a site for the display of fine art but also a place that nurtured its creation. Many of Isabella's closest friends were leaders in the arts, and the painters, composers, and scholars who visited the museum were deeply inspired by the atmosphere. Among those who enjoyed special access was John Singer Sargent, whose iconic portraits of Isabella appear in the Macknight Room and the Gothic Room. She invited him to use the latter as a portrait studio in the first few months of the museum's public opening.

Musical performances were a vital part of the life of the museum. Isabella had long held private concerts at her homes in Boston, Brookline, and Venice;

with the establishment of her museum she oversaw a more ambitious schedule of entertainments. She championed the careers of local artists from the New England Conservatory and the Boston Symphony and also promoted internationally recognized musical talents. In addition to hosting regular performances at the museum, she collected and displayed in the galleries a variety of historical musical instruments and autographed photographic portraits. The Music Room was the primary space for these gatherings before 1914, when it was demolished to create new galleries on the first and second floors.

The unique environment of the museum fired the imagination of fellow curators and scholars of art. Isabella established friendships at the nearby Museum of Fine Arts, including with its assistant director, Matthew Stewart Prichard, and the curator of Chinese and Japanese art, Okakura Kakuzo. Prichard's letters to Isabella over their long friendship explore a vast terrain of ideas related to her aesthetic, spiritual, and intellectual interests. Isabella's friendship with Okakura was similarly enriching, as the latter collaborated with her on a number of events related to his expertise in the art and culture of Japan. Through Okakura, Isabella met the poet and Nobel laureate Rabindranath Tagore, who came to discuss his poetry with her in 1913. Letters by both Prichard and Okakura, as well as poems and related ephemera, appear in cases in the Blue Room, placed there by Isabella as evidence of the depth of her relationships with each.

Isabella took great pride in her guests' reactions to her museum and saved numerous letters from visitors grateful for her decision to share her collection with them. The most poignant of these were letters from women. One letter from Mrs. Lola Greene, a teacher at the Ingalls Grammar School in Lynn, Massachusetts, encapsulates the tone of many of the writers' tributes: "As I think of the care, the time, the study, not to mention the expense that such a collection of historic and valuable articles have cost you personally, I cannot help writing that I am proud that a woman has been permitted to do this—the result of years of research and study." That Greene had brought sixty teachers from the Lynn Public Schools to visit the museum makes her letter all the more notable; in fact, Isabella made a point of saving correspondence from female educators of students of every age, from kindergarten to college. She also made her views on women's education a matter of public record, stating during an interview with a female reporter from the *Boston Sunday Post* in 1909 that the "future of our country and the soundness of the next generation will depend upon the modern college-bred woman and the uses to which she puts her training." As a longtime friend to Elizabeth Cary Agassiz, the cofounder and first president of Radcliffe College, as well as many other pathbreaking female educators, Isabella understood the importance of advancing education and

training for girls and women in the new century, and she saw the museum as a site for the cultivation of young minds regardless of gender.

Isabella took care to exhibit the work of women artists in the contemporary galleries of her museum and to promote the literary work of women within her professional networks. Paintings, sculptures, drawings, and photographs by her friends Sarah Choate Sears, Anna Coleman Ladd, Whitman, and others highlighted the artistic production of American women in her museum. Books given to her by her friends Annie Fields, Sarah Orne Jewett, Amy Lowell, and Lady Augusta Gregory attested to the strength of her interest in their writing, and her hosting of a lecture by Gregory on the subject of national theater and censorship made news in the Boston papers. Isabella highlighted the female friendships that had sustained her during the decades leading up to the establishment of her museum, and she displayed in cases portraits and letters from Julia Ward Howe, Ellen Terry, Nellie Melba, Sarah Bernhardt, and others. Her regular exhibition of these items gestures to a long-standing concern for the recognition of women's activities as vital to cultural life in the city of Boston, as well as nationally and globally.

Throughout the first two decades of the twentieth century, Isabella dedicated herself to public service through philanthropic events at the museum. Her charitable interests were extensive: between 1904 and 1921 she hosted a variety of fundraising events for disaster relief, for the disabled, and for child welfare agencies. Among these were dance performances in the Music Room to support the Massachusetts Society for the Prevention of Cruelty to Children as well as the Holy Ghost Hospital for the Incurables in Cambridge, the latter event featuring the avant-garde dancer Ruth St. Denis performing "The Cobra." Isabella saved a letter from her friend Annie Fields thanking her for an invitation to see a play held in the Gothic Room to support victims of the Messina earthquake of 1908. She served on a committee dedicated to the exhibition of "handicraft work" by disabled veterans and "foreign skilled workers" at the International Society of Industrial Arts in New York and arranged for an exhibition of amber in the Spanish Cloister of the museum to support Russian refugees in 1922.

Boston-area newspapers delighted in reporting on her generosity toward recent immigrants as well as her support of civic organizations that worked for their education and advancement. She also sought ways to engage community members in the beautification of the city. As a lifelong and competitive horticulturist—Isabella regularly won prizes from the Massachusetts Horticultural Society—she saw public gardening as an important means for civic collaboration. In 1905 Isabella partnered with the community organizer Meyer Bloomfield and a number of settlement houses in Boston to establish

Macknight Room with Anna Coleman Ladd's bust of Maria de Acosta Sargent, 1915

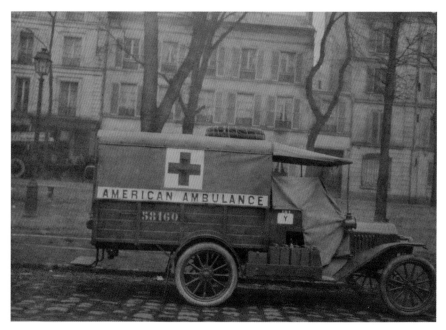

American Field Service ambulance with Gardner's preferred initial Y for Ysabella, about 1916

a tenement gardening project. The application form for this contest, which continued until 1911, indicated that "the award will consider difficulties and obstacles overcome by the applicant, as much as artistic beauty" and that "children and grown-up folks, of all ages and nationalities, are invited to take part." Isabella donated $100 in prizes for the contest and invited winners selected by a committee to a celebration at Green Hill, her estate in Brookline.

Global conflicts also made an impact on Isabella's charitable priorities in the early twentieth century and on the arrangement of art in her museum. During World War I, Isabella funded two ambulances through the American Field Service in France, an organization founded by her friend Abram Piatt Andrew, a Harvard-trained economist and former director of the United States Mint. In a letter to Berenson in 1916 she said that she was "pro only one thing and that is peace. . . . I will not give money for ammunitions and will not make money . . . by owning stock in war weapons. I call it blood money—now you know my creed."

By 1919 the museum was an established cultural entity that had captivated audiences around the world. Fenway Court had become a locus for artistic, emotional, intellectual, and spiritual cultivation. Although Isabella was confined to a wheelchair for the last five years of her life, she remained active in the management of her museum and sought ways to ensure the future of her civic legacy. She recruited the librarian at the Museum of Fine Arts, Morris Carter, as her assistant and appointed him to be the director of the museum after her

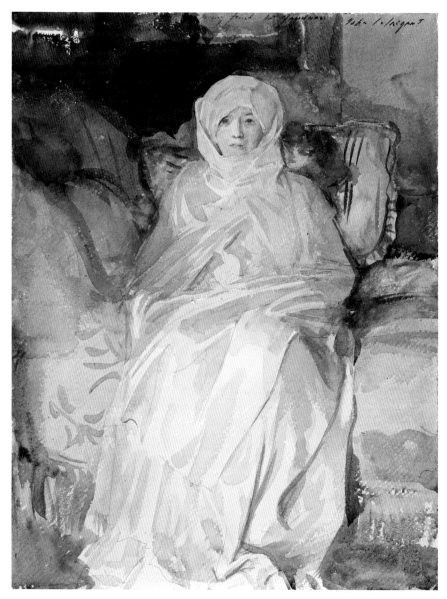

John Singer Sargent, *Mrs. Gardner in White,* 1922

death. With Carter's assistance she maintained an active and lively correspondence with friends both near and far, and she continued to entertain at the museum, though on a smaller scale. The conditions of her will, which became known after her death in July 1924, stipulated that "no works of art shall be placed [within the museum] other than such as I, or the Isabella Stewart Gardner Museum in the Fenway, Incorporated, own or have contracted for at my death." With these words she ensured the preservation of her bequest for generations of future visitors.

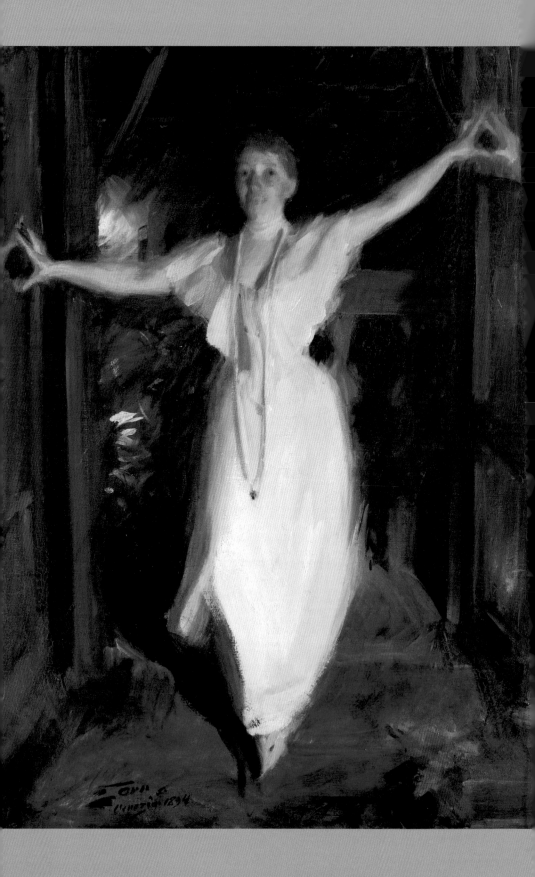

THE COLLECTION

The Swedish artist Anders Zorn sketched several portraits of Isabella Stewart Gardner in 1894: one, a close-up study of her face; the others, more traditional, seated poses that were popular at the time. Neither the artist nor the sitter was satisfied with the results, and with good reason. Not a conventional beauty, Isabella nevertheless lit up any room she was in with her exuberance, her intellect, and her fierce determination to challenge the status quo. Capturing the essence of such a dynamic spirit was no mean feat. Yet the perfect opportunity arose in the summer of that year, when Zorn attended a dinner party hosted by Gardner at the Palazzo Barbaro in Venice.

The sound of fireworks over the Grand Canal had attracted Isabella's attention, and she excused herself from the table and went out on the balcony to observe the display. With great delight, she came back into the room, throwing the doors to the balcony open wide and inviting her guests to join her. This moment provided Zorn with the pose he was seeking. He quickly sketched a portrait that he later completed in animated, impressionistic brushstrokes and vivid touches of greens, oranges, and whites playing off the night sky. Her form, suspended in motion and pushed up against the surface of the painting, explodes into the room in a flash of almost glaringly bright light, her pale skin and her sumptuous summer-white dress illuminating the room as though she herself is a source of pyrotechnic brilliance. In this spontaneous moment Zorn

Anders Zorn, *Isabella Stewart Gardner in Venice,* 1894

had found the ideal way to convey the passion and generosity of his host; she has seen something absolutely captivating and will not be satisfied until her friends come outside to share the experience with her.

In many ways, Zorn's *Isabella Stewart Gardner in Venice* serves as a metaphor for Gardner's collection and for the museum she would open to the public nine years later. She had witnessed great beauty during the travels of her childhood and early adult life, and she felt compelled to share that beauty more broadly. In fact, as Zorn was painting her portrait in 1894, Isabella was beginning an exceedingly productive decade of collecting art, with her husband by her side. Having come into her inheritance in 1891, she spent the next ten years building the bulk of an enormously impressive collection, one that she would continue to augment until her death in 1924.

THE FINE ART COLLECTION

Although relatively small in size—the art collection at the Gardner numbers about sixty-five hundred objects—it is outsized in its importance, containing some of the rarest and finest old master paintings in an American collection, including a drawing that Michelangelo made as a gift for a dear friend, Rembrandt's only seascape (stolen in 1990), and the first painting by Matisse to enter an American museum. Other marquee names of Western art history—such as Botticelli, Degas, Giotto, Manet, Piero della Francesca, Raphael, Sargent, and Titian—are represented in the collection as well.

A number of the most remarkable old master paintings came to Gardner through Bernard Berenson, a renowned scholar of early Italian painting and masterful dealer with enviable connections, particularly in Italy and England. Gardner had known Berenson since his days as a brilliant student at Harvard and had supported his early ambition to be a writer in Europe. He quickly realized that his passion, and a very lucrative business, could be found in art history and in brokering artworks. He knew that Isabella especially prized three qualities in a great painting: that it come from the hand of a master; that it have great visual impact; and that it have an august provenance. Their very telling correspondence, preserved and meticulously organized by Gardner in a case in the museum's Blue Room, proves that they both drove a hard bargain; he found her great "deals," and she negotiated unflinchingly.

She also was aided in her pursuit of rare works by a wide-ranging circle of friends—artists, curators, dealers, and scholars—who found treasures across Europe and Asia and tipped her off to them. For example, Richard Norton, the son of her mentor Charles Eliot Norton, brokered the deal of ancient sculpture from Italy for her, including the Farnese Sarcophagus. Ralph Curtis helped her acquire paintings, including Bartolomé Bermejo's *Saint Engracia*, which they

had seen at the Universal Exposition in Paris in 1900. Zorn led her to one of the most important works on paper in the collection, *A Seated Scribe* by Gentile Bellini.

For its size, the collection displays remarkable depth, covering a chronological span from ancient Egypt to early twentieth-century America, and geographic terrains from North America through Europe, North Africa, the Middle East, and virtually all of Asia. Not surprisingly, the collection is extremely varied in its range of media: examples of decorative arts, drawing, furniture, painting, sculpture, and textiles can be found in virtually every gallery. Likewise, it varies widely in quality. She bought what she wanted, whether it was a sought-after masterpiece or an eclectic trinket; she even referred to some things in her collection as "bric-a-brac."

Isabella arranged her fine art collection within a suite of galleries in the museum that transports visitors from an ancient Roman garden to the salons of grand Italian palazzi of the Renaissance. Some rooms feel very religious in atmosphere, evoking monastic cloisters or private chapels, while others prompt comparison to grand late-medieval European castle halls. Each, however, is a complete work of art in its own right, the sum of her life's work as a collector. Any single work in the collection can be understood in a number of ways: as the product of a certain artist, rooted in a precise place at a particular time—its original context—or as part of an arrangement generated in Isabella's imagination, which allowed thought-provoking and sometimes challenging juxtapositions across time and place. For example, when viewed through the frame of the Islamic and Mexican tiles that surround it in the Spanish Cloister, Sargent's *El Jaleo* takes on a meaning very different from how it would be perceived in a conventional gallery. Once visitors begin seeing thematic connections between artworks in any given room, they understand that the interpretive possibilities expand exponentially.

THE LIBRARY

The genesis of Gardner's art collection can be traced to her earlier acquisition of books, which she started to pursue in earnest decades before she had the means, or the confidence, to pursue a world-class art collection. As a student auditing classes taught by Charles Eliot Norton at Harvard, she was encouraged to buy rare editions of the Italian classics she loved, including one of her earliest great purchases, a late fifteenth-century Florentine edition of Dante's *Divine Comedy*, with illustrations engraved after designs by Botticelli. Her copy of this edition, with commentary by the Renaissance scholar Cristoforo Landino, was the first of its kind in an American collection and proudly displayed in her Dante Case in the Long Gallery. She was also given a modern

Otto Rosenheim, Isabella Stewart Gardner, 1906

copy of the text, in a lavish binding designed by Tiffany, by her close friend Marion Crawford, the contemporary novelist and dashing man about town. Two clasps that keep the book shut are incised with: "The two are one," and Crawford inscribed the volume with lines from Dante's Paradiso (33.86–87): "*Legato con amore in un volume / ciò che per l'universo si squaderna*" (Bound with love in one volume / all that is scattered throughout the universe).

Gardner amassed a collection of nearly twenty-five hundred books, ranging from contemporary paperbacks to medieval manuscripts bound in sumptuous gold-tooled leather. Known during her lifetime as "The Library," the books were prominently displayed in various galleries of the museum. They include everything from novels and poetry to scientific treatises and political works. As she did with her paintings, sculpture, and furniture, Isabella integrated books into her installations. She showcased many of her rare books and bindings in the bookcases that line the Long Gallery, including early print editions of her cherished Dante, but she also shelved works by modern authors in the same space. The Short Gallery holds books devoted to art criticism by Bernard Berenson and John Ruskin, while the Blue Room displays volumes by contemporary authors also in her circle, including Henry James, Marion Crawford, and Celia Thaxter. In the Macknight Room, which also served as her reception room and office after 1915, she placed historical works for her reference, and in the Vatichino, novels by popular authors like Bret Harte, Olive Schreiner, and Rudyard Kipling could be found.

Rightly proud of this bibliographic treasure trove, Isabella kept copious records of her books and published two catalogues: *A Choice of Books* in 1906 and *A Choice of Manuscripts and Bookbindings* in 1922. She collected and displayed correspondence and manuscripts by famous authors, such as Charles Dickens, Ralph Waldo Emerson, and Nathaniel Hawthorne. These arrangements of letters, photographs, and other ephemera reveal the breadth of her relationships with authors, as well as her connections to them, whether real or in her mind.

THE ARCHIVAL COLLECTION

These items related to authors are just a sample of over six thousand objects that Gardner displayed in fifteen glass-topped cases. Installed by Gardner at the time of the museum's opening, they house the founder's personal correspondence— including letters from over one thousand noteworthy individuals—as well as autographed letters, literary manuscripts, news clippings, coins and medals, photographs, plaster casts, pressed botanicals, and Victorian hair jewelry collected over the course of her lifetime. Her arrangement of these artifacts

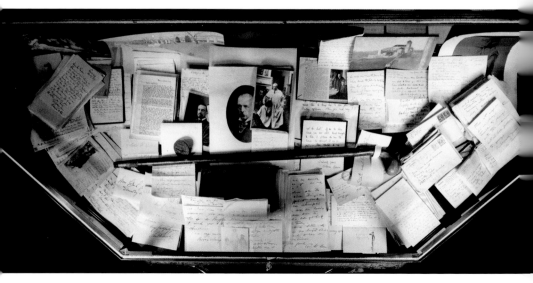

J. B. Pratt, Painters and Sculptors Case, Long Gallery

followed roughly thematic lines that illustrate the range of her interests as well as her social and professional networks. In this way, the presentations in the cases serve as another form of exhibition within the museum and reveal the scope of her civic, social, and intellectual engagement both within and beyond the fine arts.

Gardner placed these cases on all three floors of her museum, but the majority of them appear on the first and third stories. On the first floor, Gardner devoted the cases in the Yellow Room to a dazzling array of composers and musical performers, including the composer Franz Liszt and the conductor Karl Muck, as well as objects associated with musicians with whom she collaborated or musical traditions she admired. In the Blue Room, she dedicated the cases to her relationships with a number of important scholars, historians, novelists, poets, essayists, philosophers, curators, and critics of her time— including Francis Parkman, Sarah Orne Jewett, Oliver Wendell Holmes, Jr., and John Jay Chapman—in addition to authors whom she admired, such as Walt Whitman. In some instances, the content of the cases dovetails with the adjacent works of art. For example, a photo of Julia Ward Howe, a writer and activist for many causes, notably women's suffrage, appears in the case below Zorn's *Omnibus*, with its representation of women, perhaps saleswomen, traveling on public transportation. While this would not raise eyebrows today, it denoted the fact that working women had been newly "liberated" to more independent lives.

On the second floor, in the Short Gallery, Gardner devoted a single case to the life of Napoleon Bonaparte, while on the top floor, in the Long Gallery, she placed the greatest number of cases containing the broadest thematic range. In the Presidents and Statesmen Case, autographed letters from thirteen American presidents and photographs of Theodore Roosevelt and William Howard Taft appear next to a medal denoting Gardner's membership in the Hispanic Society of America and a letter from Louis Agassiz, the renowned geologist and founder of Harvard's Museum of Comparative Zoology. Other cases in the Long Gallery display her lifelong passion for the written word through mementos associated with such literary luminaries as Paul Verlaine, George Sand, Victor Hugo, Charles Dickens, Samuel Pepys, Robert Browning, and Percy Bysshe Shelley, while others memorialize her friendships with such contemporary artists as Beaux, Sargent, and Whistler through sketches, photographic portraits, and even the latter's walking stick. Still others show her admiration for theatrical performers—Sarah Bernhardt and Ellen Terry—and for European royalty, particularly Mary Queen of Scots. When taken together, the cases illustrate the liveliness of Gardner's intellectual life and her desire to communicate the fullest reach of her interests to visitors to her museum— much in the way that highly curated social media accounts do today.

The picture that emerges from the display cases is of a woman whose social network included aesthetes who championed "art for art's sake" and social progressives who advocated for the antilynching movement, women's education and suffrage, and the welfare of Boston's immigrant communities. Wherever her many friends and associates landed on the social spectrum, one salient point remains clear: her formation of a collection and construction of a museum were far from being a purely elitist endeavor. To the contrary, her lifelong quest for beauty and her desire to share it with a greater public— in this "very young country"—were informed by truly philanthropic motives.

This book is meant to guide you through the museum's galleries, whether you are visiting in person or doing some armchair traveling, to share with you some of its most important and interesting objects, and to suggest some of the many ways that Gardner's arrangements of artworks, books, and other items can be interpreted. As Zorn so vividly memorialized her, she is an eternally attentive hostess, figuratively rushing in to invite us onto the balcony to view the fireworks. With the same generosity of spirit, she has invited us all into her ultimate work of art, the museum, and we are set free to make of it what we will.

NEW WING

FIRST FLOOR

Studio

Café

Achtmeyer Terrace Garden

Entrance to Historic Building

Store

Living Room

Jordan Garden

Greenhouse Classroom

Greenhouse

Lobby

SECOND FLOOR

Calderwood Hall

Hostetter Gallery

N →

HISTORIC BUILDING

FIRST FLOOR

Worthington Street Lobby

West Cloister

Courtyard

East Cloister

Macknight Room

Vatichino

Blue Room

Fenway Gallery

Spanish Cloister

Chinese Loggia

Yellow Room

Monk's Garden

Spanish Chapel

SECOND FLOOR

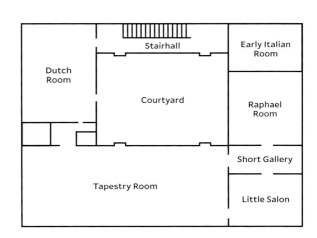

Stairhall

Dutch Room

Courtyard

Early Italian Room

Raphael Room

Short Gallery

Little Salon

Tapestry Room

THIRD FLOOR

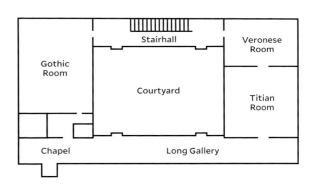

Stairhall

Gothic Room

Courtyard

Veronese Room

Titian Room

Chapel

Long Gallery

N →

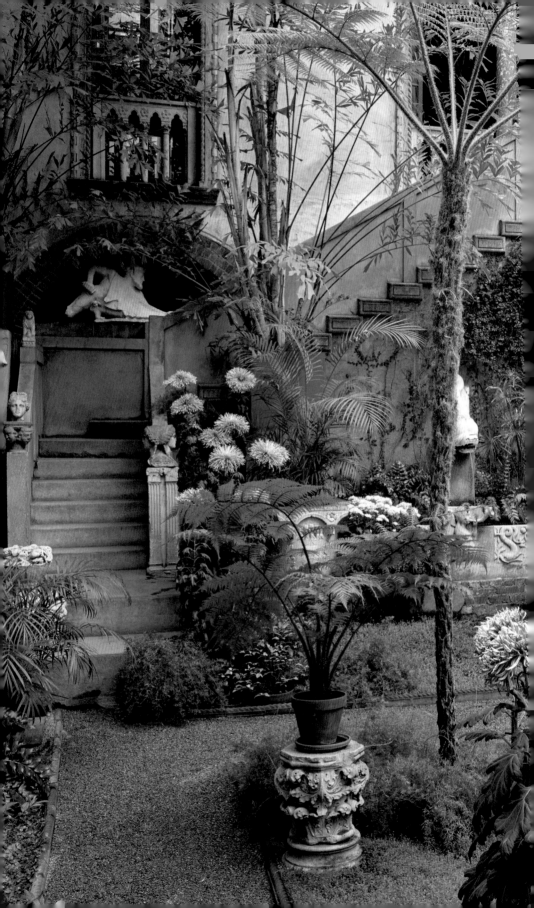

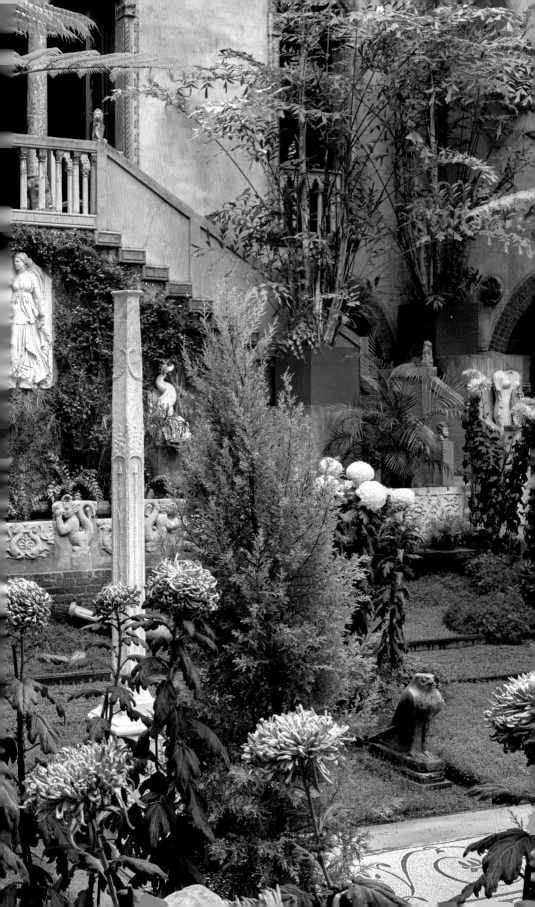

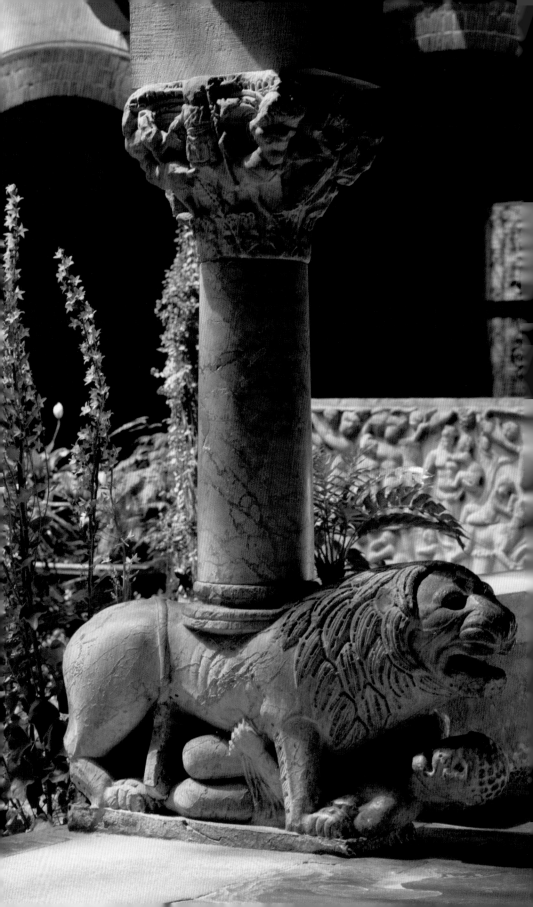

FIRST FLOOR

COURTYARD AND CLOISTERS

Visible from virtually any gallery in the museum, the Courtyard is the heart and soul of the institution. A central piazza, a gathering place for people and for dreams, it is home to several centuries of art and suggests several radically different locales: an ancient Roman sculpture garden, a Renaissance Venetian canal-scape, a medieval European cloister, and a universal exposition hall in some far-flung cultural capital. A feast for the senses—the garden delights the eye, the flowers enchant the nose, and the melodious sound of water in the fountains quickly calms the mind—it instantaneously transports visitors to another world.

At its center is a living, breathing work of art: a garden. The horticultural specimens change almost every month, from orchids in the winter to nasturtium hangings in the spring, and from hydrangeas in the summer to chrysanthemums in fall, all set amid an array of other flowers and lush ferns, shrubs, and palms. Like her grandmother Stewart, whose gardening-prize silver pitcher she displayed in the Short Gallery, Gardner had a love of horticulture. Before she opened the museum and moved into its fourth floor, she proudly displayed her gardening acumen with changing arrangements in the front window of her Beacon Street home. Her summer estate in Brookline had extensive English, Italian, and Japanese gardens.

Italian, *Stylobate Lion,* about 1200

Previous pages: Courtyard

Workshop of
Joinville-Vignory,
*Retable with Scenes
of the Passion,*
about 1425

Interspersed among the colorful plants of the Courtyard are a number of
important ancient sculptures. This installation of statues recalls the famed
gardens of the ancient Roman world, in which philosophers would stroll, look-
ing for inspiration and the answers to life's most vexing questions. The cultiva-
tion of a garden was something of a metaphor for the cultivation of the mind:
like seeds, thoughts take root and grow. In fact, a few of the sculptures in
Gardner's collection are believed to have come from two famous ancient Roman
gardens. One, said to have been found at the site of the garden of Sallust in
Rome, is an image of Odysseus surreptitiously creeping along a pediment,
here positioned on a ledge that opens on the elevator landing on the other side
of a wall. As visitors wait for the elevator to the upper floors, they can see the
well-toned physique of his backside and gain clearer insight into Isabella's
occasionally spicy sense of humor.

Gardner placed in the Courtyard a number of other Roman works that
pay homage to the beauty and power of the female figure. Very prominently
positioned over the fountain on the south side, for example, is the low-relief
marble carving of a maenad from about AD 100; she is represented with a pur-
poseful stride and a veil and clothing that flutter animatedly in the breeze.
Another Roman reimagining of an earlier Greek work, likely representing
Artemis, the goddess of the hunt, appears nearby, seemingly arrested in
motion with her weight balanced on one leg. To her left is a Roman goddess, a
Peplophoros, named for her particular type of dress, whose relatively static pose
recalls earlier, archaic Greek sculpture. In the very center—indeed, at the epi-
center of the museum itself—is a large Roman mosaic pavement (second

century AD) with the image of Medusa, a Gorgon with serpentine locks of hair, whose terrifying looks could turn men to stone. Wide-eyed and fully frontal, her masklike face gazes up at all who might look down at her from the second- or third-floor galleries.

Other sculpture from medieval European churches and monasteries can be found in the red brick Romanesque-style Cloister that surrounds the Courtyard on the museum's ground floor. These works include twelfth-century carved capitals depicting Daniel in the Lions' Den; four thirteenth-century depictions of animals in low relief from an elaborate southern Italian marble pulpit; and a Renaissance coat of arms above the door to the Spanish Cloister and Chapel. Particularly noteworthy are the scenes from Christ's Passion, carved in limestone around 1425 for a church in Saint-Étienne, Vignory (Lorraine), France. The Crucifixion is at the center of the composition, and images of a donor with John the Baptist, the Kiss of Judas, the Flagellation, and Christ Carrying the Cross are on the left, while the Deposition, the Three Marys at the Tomb, and a donor with Saint Catherine are at the right. The donors are Guillaume Bouvenot and his wife, Gudelette Bouvenot, who were buried with their son (d. 1424) in a chapel dedicated to Saint Barbara in the church at Vignory. The images of them in eternal prayer, as though witnesses to the biblical events at hand, were originally set behind the altar of this chapel.

Several other commemorative sculptural works can be found nearby. Two of them are around the corner, on the west side of the Cloisters. The first is a large and magnificently carved Roman sarcophagus (early third century AD) with a scene of maenads and satyrs gathering grapes in ritual worship of the

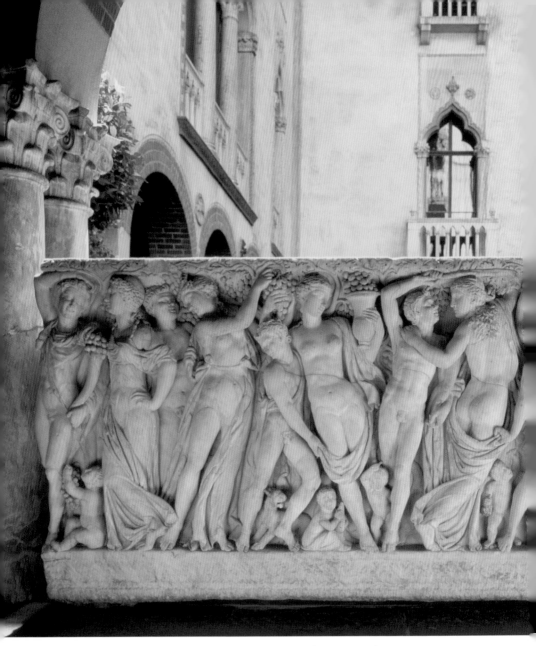

Roman, Severan, *Sarcophagus with Revelers Gathering Grapes,* about AD 225

god of wine, Bacchus. The figures' sensual, dancelike movements provide an ecstatic celebration of life on this funerary monument. Their harvest recalls the cycle of the seasons and, metaphorically, the circle of life. It is known today as the Farnese Sarcophagus because it was owned by the influential Farnese family of Rome and was displayed for several centuries in prominent palaces of the Eternal City, where it was listed in inventories and reproduced in prints and drawings by artists of the Renaissance and later.

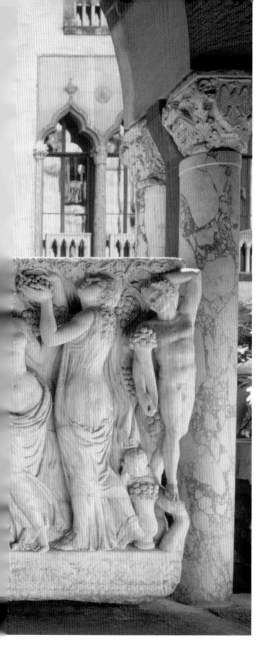

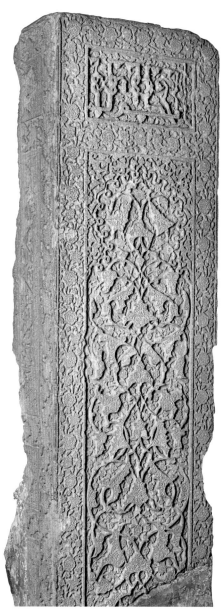

Persian, Timurid, *Fragment of a Tombstone*, about 1475

Very different in tone, yet similar in equating the abundance of the natural world with the richness of life, is the decoration found on a Timurid dynasty tombstone, carved in Herat (modern Afghanistan) in 1475 and now tucked into an alcove below the stairs to the second floor. A profusion of scrolling foliage with lotus and peony blossoms covers virtually every inch of this limestone slab, except for bands of stylized Arabic inscription at the top and on the sides which announce, "Judgment is to God. He is exalted" (Koran 22:16), and, "This is the

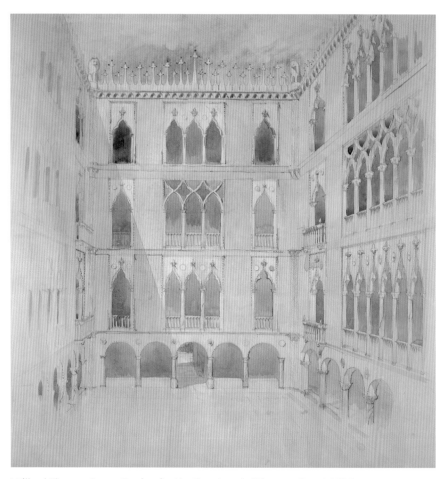

Willard Thomas Sears, *Design for the Courtyard of Fenway Court,* 1900

tomb of him whom glorious God has exalted . . . after a life of abundance in the world." Back inside the Courtyard is perhaps the most poignant piece of funeral sculpture in the collection: a child's sarcophagus of about AD 250, decorated with garlands, which many interpret as a nod to Isabella's own son, Jackie, who died in early childhood. It stands at the very center of the Courtyard, at the foot of the Medusa mosaic. By positioning this small sarcophagus, the Farnese Sarcophagus, and the Islamic tombstone in and around the garden of the Courtyard, Gardner echoed the nineteenth-century invention of landscaped cemeteries with elaborately carved monuments and mausoleums that invoke ancient architectural styles. She was herself buried in the Gardner family tomb at Mount Auburn Cemetery in Cambridge. The first landscaped cemetery of its kind in the United States, its lavish grounds, designed by Frederick Law Olmsted, became a destination for weekend strolls and Sunday picnics.

Isabella Stewart Gardner, *Travel Album of Egypt and Palestine: Girgeh,* 1874–75

In forming a transition from a Romanesque-style cloister into the façade of a Venetian palazzo, the Courtyard deliberately calls to mind the grand city where Isabella and her itinerant artistic social circle spent so much formative time. Architectural fragments, material souvenirs from the medieval and Renaissance glory days of Venice, are set at regular intervals into the fabric of the Courtyard's pink stucco walls. These include a group of thirteenth-century marble medallions with animal figures, a mid-fifteenth-century plaque with an angel and a Franciscan coat of arms, and thirty-six sets of windows or balconies with ogival or scalloped arches, porphyry and other columns, and figural or decorative capitals. This four-story architectural façade is capped with a series of papier-mâché arches that call to mind the crenellations at the top of the Doge's Palace in Venice and evoke medieval Egyptian architecture of the kind that Gardner painted in watercolor for her travel album.

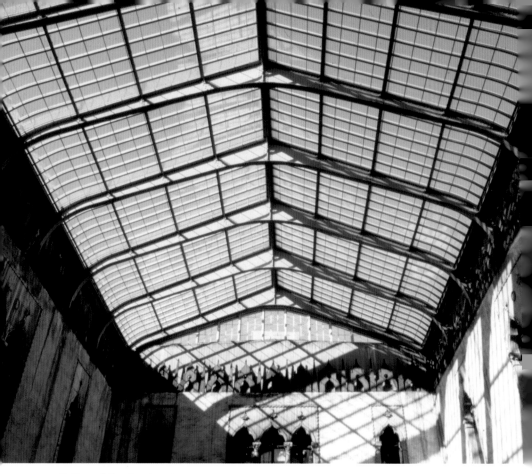

Ceiling of the Courtyard

The Courtyard is therefore, like every other gallery in the museum, a creative pastiche of styles, a juxtaposition of geographic locales and moments in time. Here, in this museum, Gardner presented thirty centuries of art, a marvelous garden, and a world of cultures, from North America to Europe to the Middle East to the Far East—all under one roof. In fact, the roof of the Courtyard itself, which is purposefully industrial in its aesthetic, underlines the quasi-encyclopedic nature of the collection. With its metal beams and glass panes giving a view of the sky, it resembles the domes of renowned pavilions of universal expositions held during Isabella's lifetime, from the arcade of the Crystal Palace of the Great Exhibition of 1851 in London to buildings such as the glass-domed Horticultural Building of the 1893 Columbian Exposition in Chicago, which Isabella and Jack Gardner supported with a loaned painting and to which they traveled. Like those buildings at the expositions, Isabella's palace brought the world, or at least her version of it, to Boston.

Nonetheless, the Courtyard was never intended as a static display; instead, it was a dynamic organism very much in tune with the natural world. Each

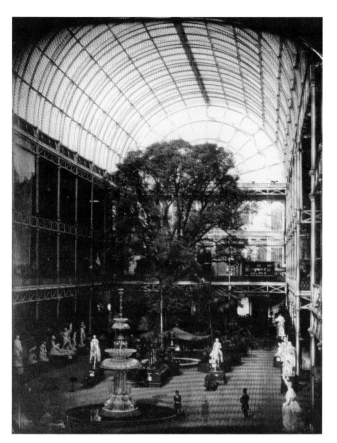

The Crystal Palace at Hyde Park, London, 1851

month, the horticultural display changes. Every day, sunlight creates dynamic patterns of light and shadows across the pink stucco walls and radiates through doors and windows into the other galleries. People, too, animate the space with conversation and movement. On special occasions, performances take place in the Courtyard, as they did in Isabella's time, when luminaries like the famed soprano Dame Nellie Melba sang from the landing of the stairs above the fountain. The appearance of the Courtyard, with its four stories and its view through glass to the sky, along with the memory of performances of the past that have reverberated off its walls, served as more recent inspiration for the architect Renzo Piano, who designed the Gardner Museum's new Calderwood Hall, in which performers play in the round. Now, as in the past, the dreams that take place in the Courtyard extend far beyond the physical dimensions of the space. It is, in a word, transformative.

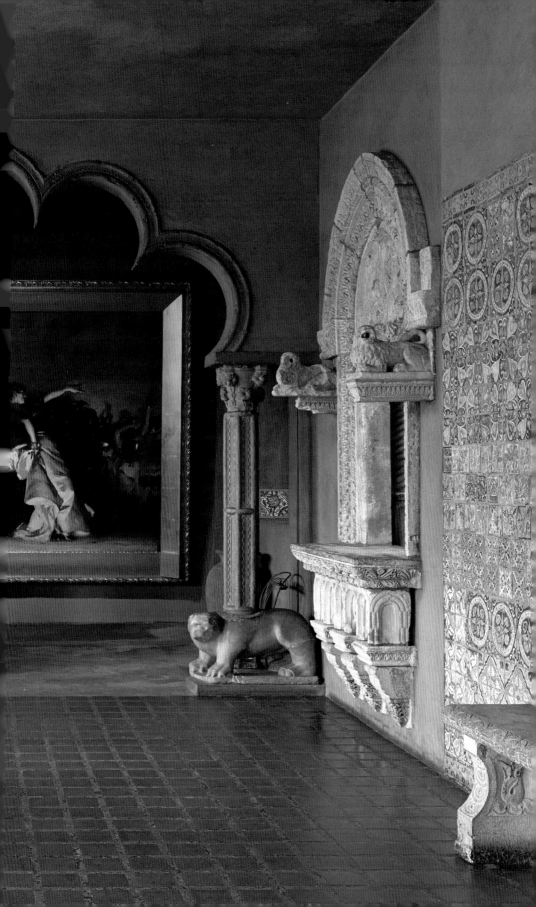

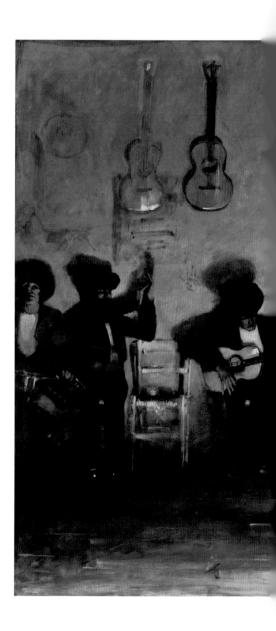

John Singer Sargent, *El Jaleo*, 1882

SPANISH CLOISTER AND SPANISH CHAPEL

Holding a rhythmic procession of colorful tiles, ancient sarcophagi, and archi-
tectural fragments, the visually arresting corridor of the Spanish Cloister
reaches its crescendo in one of the Gardner Museum's most iconic and enchant-
ing paintings: John Singer Sargent's *El Jaleo* (The Ruckus). As the first paint-
ing encountered, it dramatically set the stage for a walk through the Gardner,
boldly proclaiming that this was not going to be a regular museum experience.
Rather, it was to be a veritable feast for the senses—loud, beautiful, moving,

Previous pages: Spanish Cloister looking south

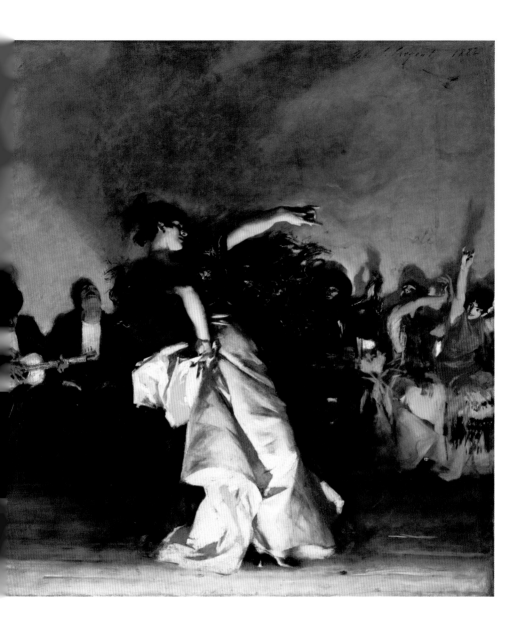

inspirational, occasionally jarring, anything but ordinary. With this gallery, Gardner invited us all to join in the dance.

The Spanish Cloister, like the Tapestry Room directly above it, was carved out of the museum's original two-story Music Room, the location of many lauded performances and lectures from 1903 until 1914. By placing *El Jaleo* at the site of the former stage at the gallery's south end, Gardner preserved for perpetuity the theatrical nature of the space. Painted in 1882, this whirlwind of light, shadow, sound, and frenzied movement captures the ecstatic spirit of flamenco concerts in Spain, a country through which both Sargent and Gardner had traveled. The impossible contortions of the central dancer's arms

and the flashes of vivid greens in the feathers of her top testify to the passions unleashed by the music. The seated performers in the background, likewise, can barely contain their emotions as they throw their heads back in song or raise their arms to the ceiling with abandon.

This painting was originally purchased by T. Jefferson Coolidge, who promised Isabella it would one day be hers. To hasten the gift, she constructed an installation that mixes elements of Old World Spain and New World Spanish influence. A scalloped cement archway in front of the painting recalls the Hispano-Moresque history of the Iberian peninsula, as do the marble capitals and columns that hold it up; two carved southern Italian marble animal bases support them in turn. Gardner also originally lit the painting from below, a reference to the glaring floodlights that brilliantly catch the dancer's white satin skirt and cast a tornado-like shadow on the wall behind her. By putting a mirror on the wall to the left of the painting, Gardner expanded the scene and broke the fourth wall of the stage, making the viewer feel as though he or she has become immersed in the space as well. When Coolidge saw the magnificent stage that Isabella had set, he had little option but to give *El Jaleo* to her for the museum. Sargent, for his part, was so thrilled to see it displayed in such a manner that he presented Gardner with an album of preparatory drawings for the painting as well as a collection of early flamenco recordings, still preserved in the museum's archives.

A number of other works in the space evoke the Islamic influences on Spanish art and on the eventual influence of Spain in the New World. Several medieval Islamic tiles surround *El Jaleo;* they include a thirteenth-century cobalt and lusterware-glazed mihrab tile with a fragment of Arabic text from Iran (Kashan) and a Turkish (Iznik) tile with tulips and other flowers, from about 1575. The pottery studios in the New World, crucial hubs in the trans-oceanic trade between Europe and Asia, were heirs to the technology of luster-ware and glazed ceramics, invented and perfected in the medieval Islamic world. In Mexico, in particular, Talavera-ware ceramics emulated and then reinvented the blue-and-white-ware that was coveted and traded for centuries between continents. In 1909 the artist Dodge Macknight, a dear friend of Gardner's, purchased on her behalf a group of seventeenth-century glazed terracotta tiles from the church of San Agustìn in Puebla, outside Mexico City. She spent hours arranging the nearly two thousand tiles, decorated with geometric and foliate designs as well as human figures, into their current configuration along both sides of the Spanish Cloister.

A series of architectural fragments and sculpture rounds out the arrangement in this Cloister. Among these is a twelfth-century limestone portal from a private house in La Réole, France, that leads from the East Cloister of the

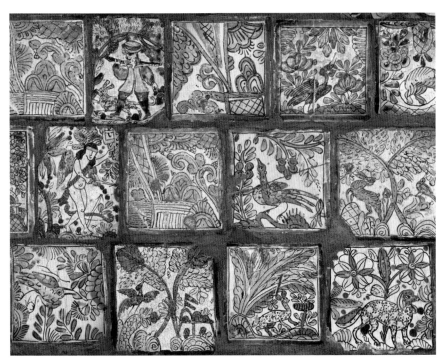

Mexican, Puebla, *Tiles from the Church of San Agustin, Atlixco, Puebla,* 17th century

Courtyard into the Spanish Cloister. Something of a pastiche, it has a scalloped archway, perhaps the inspiration for the modern cement one that frames *El Jaleo;* figural capitals; and three heads inserted into the scallop design, over a lintel elaborated with the ancient Greek meander pattern. Several sarcophagi appear along the walls; some were put in place by Gardner herself, and others were moved from her house in Brookline, Green Hill, after her death. Particularly eye-catching among the sarcophagi is the one showing a fountain flanked by peacocks. Ancient in structure, it bears nineteenth-century carving done in the style of late Roman sarcophagi from Ravenna, Italy. Just up the stairs, on a landing, are two limestone ensembles, from about 1150, surrounding the door to the Fenway Gallery. Created for the façade of the church of Notre-Dame-de-la-Couldre, in Parthenay, France, they represent Christ Entering Jerusalem and Two Elders of the Apostles.

Behind a decorative wrought-iron gate, from a synagogue, is the small Spanish Chapel. A solemn, commemorative alcove, it features an altar set with textiles, other liturgical furnishings, and a painting of the Virgin of Mercy from the workshop of Francisco de Zurbarán. Stained-glass panels with saintly figures and noble coats of arms are set into the window nearby. One of these, *The Self-Mortification of Saint Benedict,* shows the saint hiding in a thorny bush

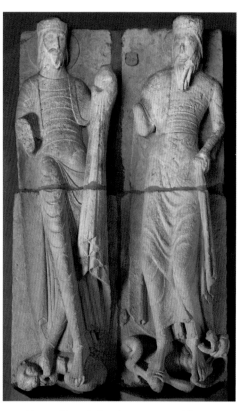

Above: French, Parthenay, *Two Elders of the Apocalypse,* mid-12th century (with later additions)

Right: Spanish Chapel

to overcome his lust for the beautiful woman seated on the right. It was designed by Albrecht Dürer in 1496 for the Waldstromer family, whose arms appear on the left, and was originally placed in the Benedictine abbey of Saint Aegidius in Nuremberg. A nearly life-size alabaster tomb figure of a knight, carved in Spain just before 1500, is installed before the windows. When Gardner died in 1924, her body was laid out for viewing in this space, next to

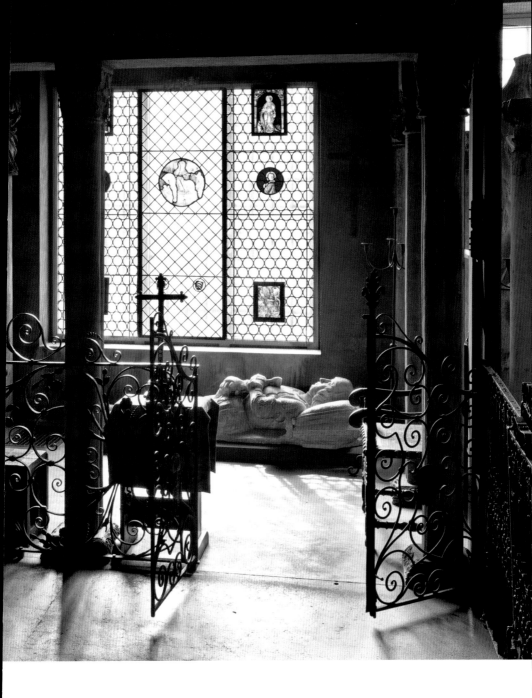

this knight. Appropriately, her friend Joseph Lindon Smith had painted in
gold letters the words from a medieval Spanish inscription, just visible on the
upper wall between the Spanish Chapel and the Chinese Loggia. It begins,
"In Memoriam," and continues around the wall to the right but is visible only
from within the Chapel itself. Like so many other places in the museum, it hints
at something, only to leave the interpretation up to the viewer.

CHINESE LOGGIA

With its large windows facing the Monk's Garden, the Chinese Loggia functions as a transitional space between the lush greenery of the museum's central Courtyard and the allure of the natural world outside. Quiet, contemplative, and flooded with light during the day, this space and its contents show Gardner's ecumenical approach to collecting and displaying art, and they point to her profound interest in and respect for different religious practices.

At one end, this gallery culminates in the Spanish Chapel that is visible behind a nearly life-size limestone *Virgin and Child*, carved near Paris in the 1300s. Hanging lamps and a tall candelabrum nearby give this a chapel-like feeling, while colored fragments of stained glass from Reims Cathedral—gathered from windows shattered during World War I by an American ambulance driver and set into a panel by Henry Davis Sleeper, Gardner's friend and a fellow collector—offer a poignant reminder of the frailty of human lives and cultural monuments in wartime. In addition to potted plants and a trellis arching overhead and along the windows, the Loggia is accentuated with fragments of ancient and medieval marble sculpture, including decorative column capitals, cinerary urns and sarcophagi, and a Greek or southern Italian torso of Dionysos or Apollo from about 50 BC.

The other side of the gallery is vastly different in style and theme, and is devoted primarily to art from Asia. A mirror at the end of the gallery adds a theatrical effect and changes the light in the space; it also reminds visitors that the objects here are positioned on a direct axis with the ancient and medieval European art at the other end. The most prominent object on this side is a large Chinese votive stele, with an image of the Buddha Shakyamuni, the prince-turned-ascetic whose teachings form the basis of Buddhist thought, in the center of the stele's front; he is surrounded by two disciples and by the bodhisattvas, or enlightened beings, embodying compassion and wisdom. Carved from limestone in AD 543, during the Eastern Wei dynasty, it bears an inscription on its base that a certain Luo Zikuan and seventy other donors had this statue made for the emperor, with the hopes that all sentient beings would conform to the Buddha's way and thereby find universal salvation.

Farther on, on either side of a staircase leading down, are displayed a number of decorative items that bring to mind the environs of a Buddhist temple or a house shrine. They include medieval Japanese foo dogs, a large gong, and a stone lantern. At right, a noteworthy painted and gilded Chinese statue of Guanyin, the bodhisattva of compassion, perches on a ledge. While generally represented as a female figure, this eleventh- or twelfth-century statue takes a male form, indicative of compassion's boundless properties that transcend gender. Guanyin, which can be translated from the Chinese as "the one

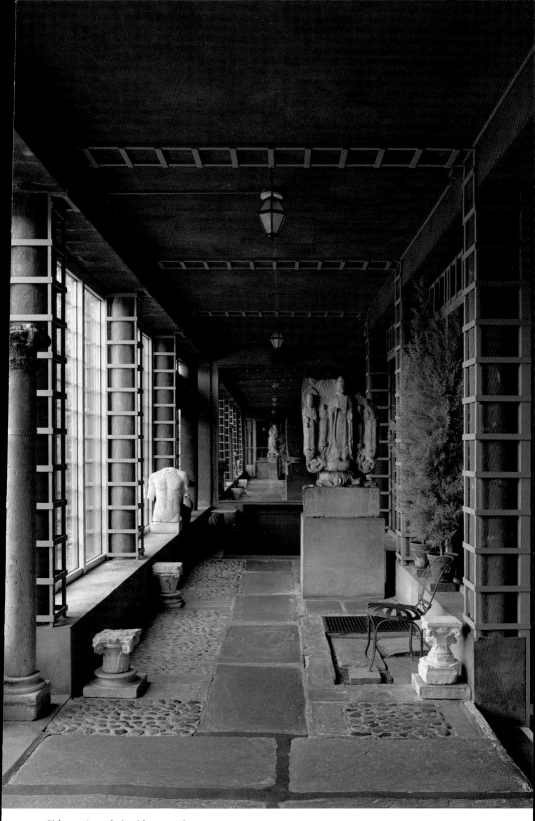

Chinese Loggia looking south

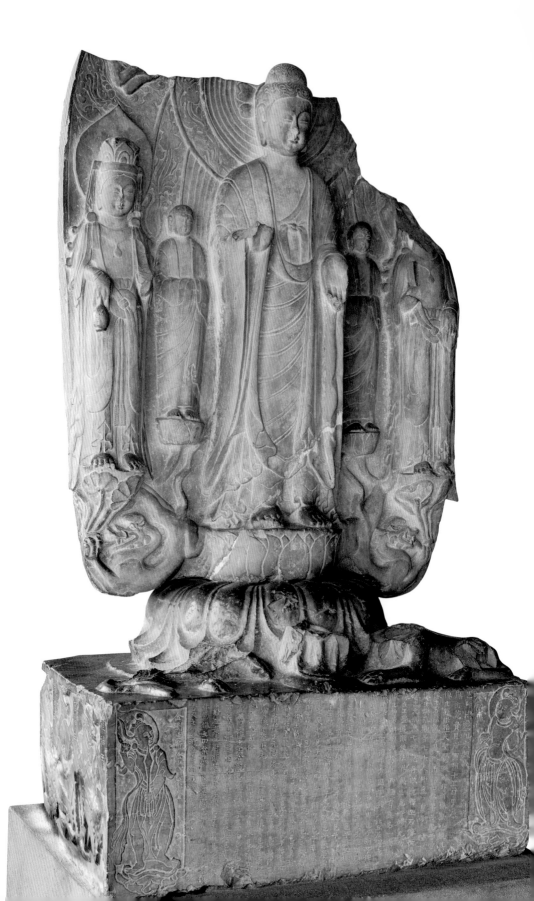

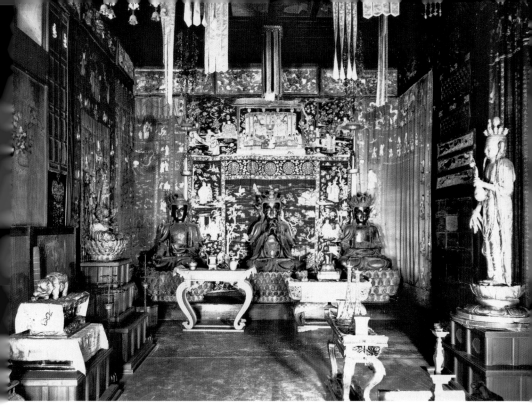

Second Chinese Room, 1961

who heeds the cries of others," was first worshipped in India, and this deity is appropriately outfitted here in the sumptuous garb of an Indian prince.

The staircase once led to a semiprivate space that Gardner created as something of a personal shrine in 1914. Templelike in appearance, it housed an extensive collection of Asian art, including a profusion of painted screens, sculpture, and textiles, all lit by a small window and an array of incense burners, lamps, and candles. In memoriam to her friendship with Okakura Kakuzo, who died in 1913—the son of an ex-samurai merchant who became an educator, poet, historian, and curator of Chinese and Japanese art at the Museum of Fine Arts, Boston—and also inspired by her earlier travels throughout Cambodia, China, Japan, India, and Indonesia, she constructed a highly idiosyncratic display of domestic and devotional objects mixed with personal memorabilia.

Rarely accessible to the public in her lifetime, this subterranean gallery was not considered by later generations as part of the historic collection, which is mentioned in her will as being on the first, second, and third floors. In 1971 a number of items from this Chinese Room were sold at auction and the stairs were covered over until a renovation in 2011. Other artworks were moved to new places in the historic building. A pair of folding screens with scenes from

Chinese, Eastern Wei dynasty, *Votive Stele,* AD 543

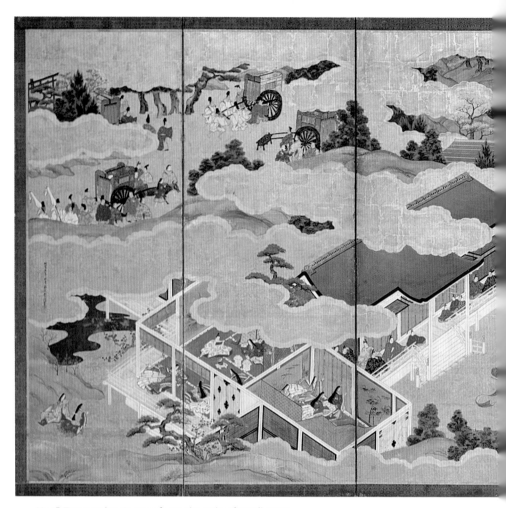

Kanō Tsunenobu, *Scenes from the Tale of Genji,* 1677

The Tale of Genji, for example, was relocated to the passageway by the elevator on the third floor. Here, the late seventeenth-century painter Kano Tsunenobu has depicted vignettes from the twelve chapters of this famous novel, itself written around AD 1000 by Murasaki Shikibu, a lady-in-waiting at the court of Kyoto. Against a brilliant gold background and nestled amid the clouds, scenes of courtly intrigue take place, all relating to the dashing protagonist, Genji, a reputed master of all arts and a skillful lover.

Gardner also had reconfigured a former Chinese Room and moved some of its contents down to this "Second" Chinese Room in 1914. In her inaugural gallery installation of 1903, the current Early Italian Room was devoted to a mixture of styles, including Asian and European art, and named the Chinese Room. Many other American mansions at the time boasted such rooms featuring an exotic blend of arts from Asia. This fashion for Asian aesthetics may

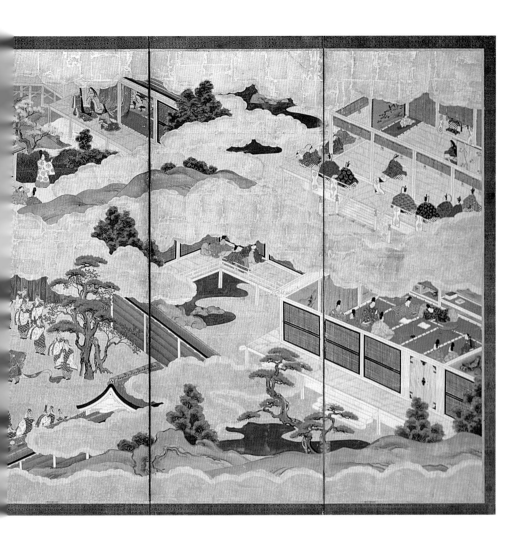

have held special resonance for old New England families like the Gardners, who had profited from mercantile connections between Salem and Chinese ports for generations. More recent events, like the reopening of Japan in the 1850s and Gardner's close friendships with such local aficionados of Japanese art as William Sturgis Bigelow, an early and exceedingly generous donor of Japanese art to the Museum of Fine Arts, Boston, certainly furthered her enthusiasm for Asian art. Bernard Berenson, known for helping her make enviable acquisitions of Italian art, also facilitated her purchases of Chinese and Persian art. As though to signal her personal connection to such works, she placed her portrait by Anders Zorn, now on view in the Short Gallery, just to the right of the fireplace in her First Chinese Room.

Some important vestiges of the museum's First Chinese Room can still be found in the Early Italian Room, including a case with jade carvings, Persian

Thomas E. Marr and Sons, First Chinese Room, 1903

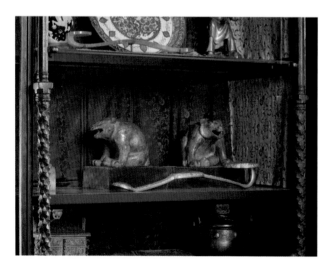

Chinese, Western Han dynasty, *Mat Weights: Bears,* about 206 BC–AD 9

Italian, Rome, *Chair Painted with Exotic Figures,* 1825–50

lusterware ceramics, and two bronze mat weights in the shape of bears. Dating to the Han dynasty (206 BC–AD 9), the bears were meant to hold down straw or textile mats that covered low seating. Charmingly naturalistic, with one hind lug tucked playfully in front, they have each been caught with their mouths open, as if making a sound. They were unearthed in Xi'an in 1900 and may owe their realistic appearance to the fact that the Han emperor Wudi kept bears in the royal zoo there. Other remnants from the First Chinese Room, such as a set of nineteenth-century Italian wooden chairs painted with exotic figures, speak to early European depictions of the Far East. On these chairs, Asian figures, with fanciful turbans and billowing pants, are rendered in classic Rococo pastels with golden frames. Like Gardner's Chinese Rooms, they are a hybrid of European and Asian aesthetics.

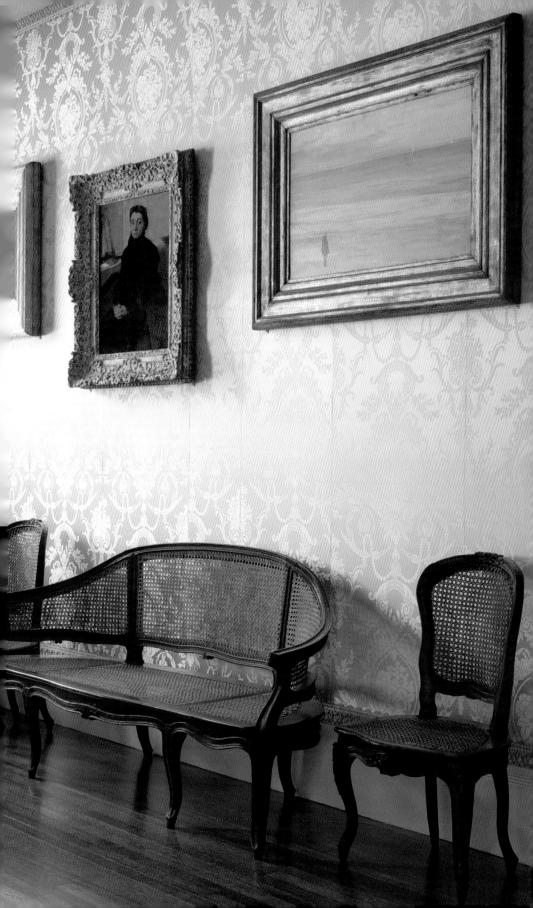

YELLOW ROOM

Originally located near the public entrance and the museum's former concert hall, the Yellow Room showcases two of Isabella Stewart Gardner's great passions: music and the art of her time. The art on the walls and the items in the vitrines evoke the wide range of her interests in musical traditions and genres, and also the depth of her relationships with composers and performers. At the same time, the gallery houses some of the museum's most significant modern paintings, many of which were acquired through Gardner's relationships with the artists who helped her to build her collection. The relatively small size of the room, combined with the marigold-colored wall coverings and personal nature of many of the objects on view, conveys a sense of warmth and intimacy, and invites visitors to consider the more contemporary elements of Gardner's collection at close range.

Three cases with deliberate arrangements of archival materials line the western and northern walls of the room. They illustrate, in particular, her relationships with musical performers. Letters from Wilhelm Gericke, Charles Martin Loeffler, Karl Muck, Nellie Melba, Francesco Paolo Tosti, and Anna Pavlova attest to the strength of her connections to these talents, and autographed photographs of Ignace Paderewski, Johann Strauss, Johannes Brahms,

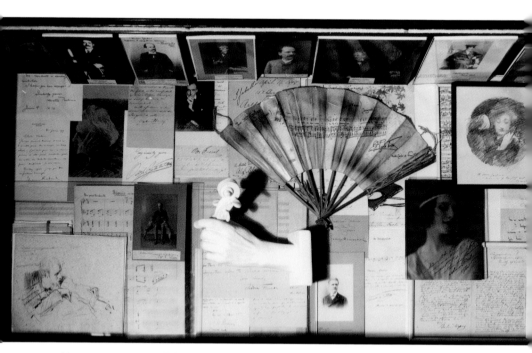

Above: J. B. Pratt, Musicians Case, Yellow Room

Previous pages: Yellow Room looking northeast

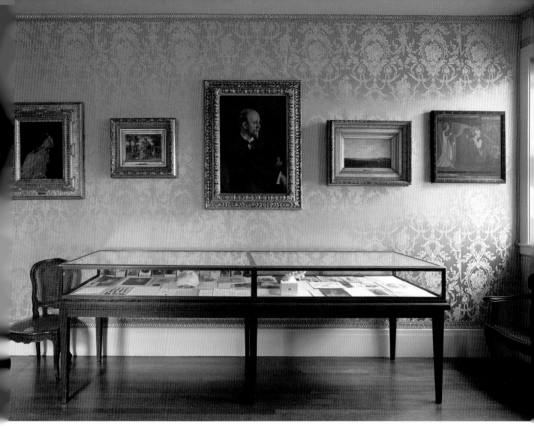

Yellow Room looking west, with the Musicians Case, John Singer Sargent's portrait of Charles Martin Loeffler, 1903, and Dante Gabriel Rossetti's *Love's Greeting*, about 1861

and Eugene Ysaye make her social ties to these artists all the more visible. Gardner also collected artifacts associated with artists with whom she was not personally acquainted, evidenced by letters and photographs of Beethoven, Berlioz, Liszt, Mendelssohn, Saint-Saëns, Richard Strauss, and Wagner, as well as a musical score by Tchaikovsky. The firsthand nature of her connections to many of these composers, conductors, and performers is especially evident in Gardner's playful inclusion of several plaster casts within the case, including a cast of Loeffler's hand holding the neck of a violin and Liszt's hand holding that of a student, as well as a filigree box containing a lock of Liszt's hair.

Gardner's choice of paintings for the Yellow Room reflects the breadth and depth of her artistic patronage beyond her musical interests. Above the cases on the western wall of the Yellow Room is Sargent's portrait of Charles Martin Loeffler, a birthday gift to Isabella from the artist to a longtime patron and friend of the musician. Loeffler was an important figure in Gardner's circles, and she often hosted musical programs that included Loeffler's compositions. In fact, Sargent completed his portrait of the composer in the museum's Gothic Room in 1903. To the right of the Loeffler portrait is Dante Gabriel Rossetti's *Love's Greeting*, the only Pre-Raphaelite painting in the museum.

The painting is based on the frontispiece to Rossetti's first published translation of early Italian poetry, a topic close to Gardner's heart.

The eastern wall of the Yellow Room showcases two atmospheric paintings by James McNeill Whistler, *Nocturne, Blue and Silver: Battersea Reach* and *Harmony in Blue and Silver: Trouville,* as well as Edgar Degas's striking portrait of the dancer Joséphine Gaujelin. Gardner collected several drawings and a watercolor sketch by Degas but selected this unusual portrait of a dancer—seated and in street clothing—as the only oil painting by the artist for her collection. Gaujelin's unsmiling visage and tightly clasped hands suggest an attitude of defiance as she faces her audience, her posture communicating a refusal to perform. In contrast, the serene haze of the landscapes to the right and left of Gaujelin's portrait stand in tranquil counterpoint and remain important symbols of Gardner's relationship with Whistler. Although Gardner held Whistler in the highest esteem and devoted a case in the Long Gallery to his memory after his death, their relationship was not without moments of drama. In one instance, Gardner reportedly became impatient with the artist's forestalling her acquisition of *Harmony in Blue and Silver.* In a typically direct fashion, she arranged to visit Whistler's studio with an acquaintance, and after tea announced, "This is my picture; you've told me many times that I might have it, Mr. Whistler, and now I'm going to take it." Gardner and her accomplice carried the painting down the stairs with the artist protesting in their wake, but the matter was soon resolved, and he signed the painting at her hotel the next day.

On the south wall of the Yellow Room, several smaller works—including Sargent's *Mrs. Gardner at Fenway Court*—are arranged around the museum's only painting by Henri Matisse, *The Terrace, Saint-Tropez.* Isabella's friend Thomas Whittemore, an art historian and archaeologist whose portrait by Sargent appears in the Macknight Room, was a part of Matisse's circle in Paris. Whittemore's gift allowed Gardner to incorporate a representative work of the twentieth-century avant-garde into her collection; in fact, *The Terrace, Saint-Tropez* became the first painting by Matisse to enter an American museum, in 1910. The painting depicts the artist's wife, Amélie, sitting with her back to the wall of their home in the south of France, her hands busy with a bit of work in her lap. The shadow of the house offers her refuge from the intense sunlight that slices into the terrace, illuminating the brilliant azure of the sky and the periwinkle fathoms of the sea beyond, while verdant tendrils and a profusion of roseate flowers suggest the abundance of the surrounding landscape.

A small watercolor by Joseph Mallord William Turner, *The Roman Tower, Andernach,* one of a series of paintings the artist made following an extended sketching trip along the Rhine, appears in a prominent position opposite the door to the gallery. Although Gardner purchased relatively few paintings by

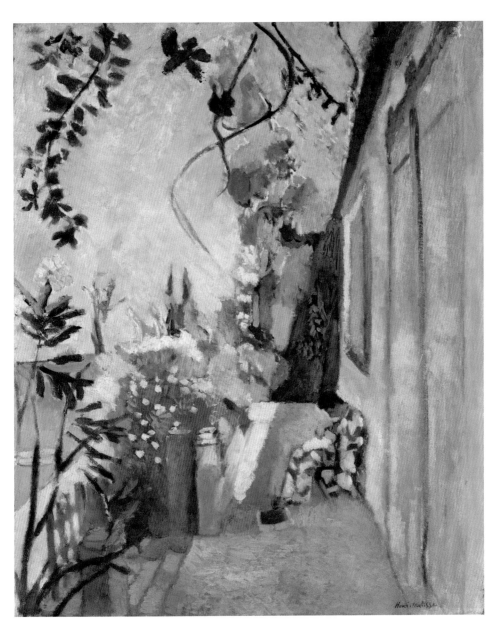

Henri Matisse, *The Terrace, Saint-Tropez*, 1904

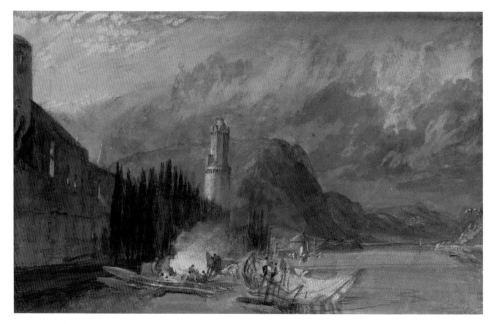

Joseph Mallord William Turner, *The Roman Tower, Andernach,* 1817

British artists, she traveled extensively in England and maintained business relationships with some of the most important booksellers, gallerists, and art dealers in London. As an avid traveler and sometime sketch artist on her journeys, Gardner might have enjoyed the impromptu, exploratory nature of the landscape in *The Roman Tower, Andernach.* Turner drew numerous graphite sketches while traveling along the Rhine and created a series of watercolors based on those drawings when he returned to England. *The Roman Tower, Andernach* is therefore as much the result of the traveler's imagination and memory keeping as it is a faithful rendering of the site itself. Gardner's placement of the only Turner in her collection at the entrance to the Yellow Room suggests a desire to draw attention to the painting, whose scale belies its importance as a work by one of the foremost landscape painters of the nineteenth century.

A cabinet set along the south wall of the gallery holds an assortment of ceramics from Asia, Europe, and the Middle East. Twenty-four pieces of Worcester armorial china that Gardner thought belonged to Marie Antoinette are inscribed in French with the admonition "Know Thyself." Gardner was relatively circumspect when it came to giving advice, although she held a few choice mottoes for herself; the motto for her racing horse stable was "Win as though you were used to it, and lose as though you like it." Small riddles or directives like the one on the china pop up throughout her museum, revealing a great deal about the personality of the woman behind its creation.

FENWAY GALLERY

Between the Yellow Room and the Blue Room is a gallery space that once served as the original public entrance to the museum. When the new wing of the museum opened to the public in January 2012, this entryway was converted into a gallery for small-scale special exhibitions. The floor of the gallery is notable for its beautiful and varied arrangements of glazed terracotta tiles from the Moravian Pottery and Tile Works of Doylestown, Pennsylvania, established in 1898 by Henry Chapman Mercer, a self-trained archaeologist who became interested in the preservation of historic craftsmanship. The distinctive, hand-made tiles produced by his factory were designed by Mercer himself, who had studied with a German potter and applied his knowledge of historical archaeology to the fabrication and ornamentation of his tile work. Gardner was deeply interested in supporting traditional craftsmanship both locally and nationally, and she counted Mercer among her friends. Mercer and Gardner worked closely to select the designs for tiles that would be used throughout the museum, and their choices reflect a shared interest in the ornamentation of medieval architecture. The tiles in the Fenway Gallery show Mercer's reinterpretations of historic design motifs, including many from his Medieval series and nearly all from a line dedicated to Castle Acre, a Norman castle in England. Mercer tiles appear in other gallery spaces throughout the museum, including the stair halls, the Early Italian Room, the Raphael Room, the Tapestry Room, the Dutch Room, the Veronese Room, the Long Gallery, the Chapel, and the Gothic Room.

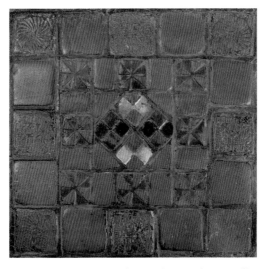

Moravian Pottery and Tile Works, *Castle Acre Tiles,* about 1901

Following pages: Blue Room looking northeast

BLUE ROOM

Like the Yellow Room, the Blue Room is a gallery brimming with objects reflective of Gardner's personal relationships. In the early days of the museum the Blue Room served as a ladies' reception area and was well situated for concertgoers. Today the Blue Room offers an informal environment for displaying the work of artists in Gardner's closest circle of friends. With its low ceilings, fabric-covered walls, and well-lit alcoves showcasing paintings, furniture, books, and cases, the Blue Room invites visitors to explore the collection in an atmosphere of domestic serenity.

Édouard Manet's *Madame Auguste Manet* dominates the south wall of the room. Clad in the charcoal hues of a widow's attire, Madame Manet faces the viewer with a determined gaze, her gray eyes steady beneath the broad arches of her brows, the firm line of her mouth puckered at one corner as if ambivalent about the artist's scrutiny. Gardner herself had been widowed for more than a decade when she acquired the painting in 1910, yet her purchase arose from a fierce desire to garner a portrait by one of the most celebrated French painters of the nineteenth century; Berenson advised that it would be essential to her "matchless collection." Directly beneath the portrait of Manet's mother was the artist's rendering of a top-hatted, keen-eyed man sketching at a Parisian café, *Chez Tortoni*, a work that Gardner said she was "delighted" to add to her collection; sadly, it was one of the works stolen from the museum in 1990. Gardner's purchase of it in 1922 and its original installation in the Blue Room indicate the strength of her interest in contemporary art—even near the end of her life. In the dozen years between her acquisition of these two works by Manet, Gardner was appointed an honorary vice president of the International Exhibition of Modern Art at the 69th Regiment Armory in 1913. Her placement of these paintings in close proximity to the original entrance to the museum suggests a desire to highlight her discernment as a collector of the art of her time.

On the projecting section of the south wall, visitors may view two works in different media by Sargent: *The Scapegoat*, a gilded plaster medallion modeled in preparation for his mural decorations for the Boston Public Library; and *Ponte della Canonica*, a watercolor view of a light-dappled Venetian canal. Gardner and Sargent enjoyed a genuine and mutually beneficial friendship from the 1880s until her death, and the installation of these two works highlights their shared interests in the cities of Boston and Venice. Gardner actively promoted Sargent's commissions within her home city and asked for the artist's casts for the decoration of the library; she perhaps placed these casts throughout the Blue Room and the Macknight Room as emblems of her efforts to enrich civic institutions in Boston. Conversely, *Ponte della Canonica*—and other early twentieth-century watercolor views of Venice in the Blue Room, including

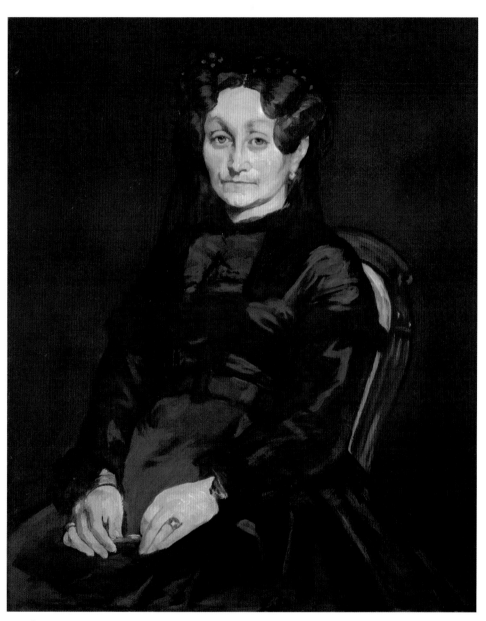

Édouard Manet, *Madame Auguste Manet,* 1863

John Singer Sargent, *San Giuseppe di Castello,* Venice, about 1903

San Giuseppe di Castello and *Santa Maria della Salute*—reflect Sargent and Gardner's admiration for the architecture and atmosphere of the waterways in the historic lagoon city. Sargent's watercolors of Venice present an immediate vision of the city, the sunlit pediments and rotundas cropped to reveal his proximity to them.

 Beyond the projecting portion of the south wall, a low bookshelf and glass-topped case house a portion of Gardner's book collection, as well as personal correspondence and photographs. The case features a selection of materials related to Gardner's friendships with contemporary authors, including Henry James, John Jay Chapman, William James, Oliver Wendell Holmes, William Dean Howells, Oliver Wendell Holmes, Jr., and Francis Marion Crawford. A plaster cast of the abolitionist poet John Greenleaf Whittier's hand also appears in the case, appropriately located above published volumes by female authors he had championed and who were friends of Gardner's, including Celia Thaxter and Sarah Orne Jewett. In addition to bound volumes, the bookcase contains original manuscripts by the poets Henry Wadsworth Longfellow, William Cullen Bryant, and others. Gardner was an avid reader of nearly every conceivable genre, from novels to epic poetry to the work of contemporary historians, and was a serious collector of books and manuscripts throughout her life.

Dennis Miller Bunker, *Chrysanthemums,* 1888

 The western wall of the Blue Room showcases more works by artists within Gardner's circle of friends. Dennis Miller Bunker's *Chrysanthemums* pays tribute to Gardner's prizewinning horticultural talents in its vibrant depiction of the vast banks of white, red, pink, and gold chrysanthemums in the greenhouse of her Brookline estate. Two portraits on the same wall were painted by artists close to Gardner, including a portrait of the Museum of Fine Arts curator John Briggs Potter by the art historian Denman Waldo Ross and a portrait by Anders Zorn of Mrs. Grover Cleveland. Other small works by significant artists of the late nineteenth and early twentieth centuries are gathered on this wall, including a pastel by Childe Hassam, *A New York Blizzard;* Gustave Courbet's *A View across the River;* and two watercolors by John La Farge, *The Recording Angel* and *The Spirit of the Water Lily.* Sargent's study of his campsite during a Canadian painting trip, *A Tent in the Rockies,* reveals the rustic glory of his impromptu tent, crafted with birch boughs and blindingly white canvas.

 In the alcove on the left-hand side of the Blue Room's northern wall, three cases holding correspondence, photographs, and other aides-mémoire stand beneath several more paintings by Sargent and an oil painting by Zorn. Sargent's *Incensing the Veil,* a dreamy watercolor of a North African woman inhaling the smoke of burning ambergris, hangs near several other of his works, including the watercolor *Bus Horses in Jerusalem* and a portrait sketched in oil,

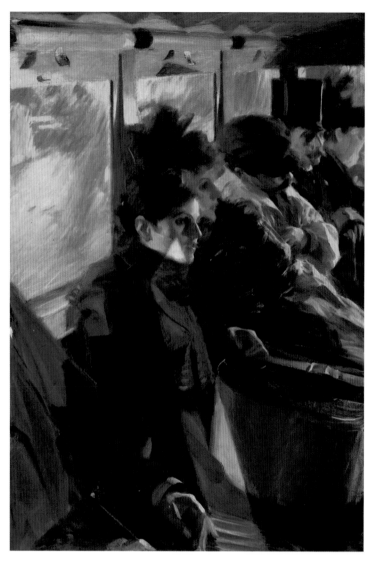

Anders Zorn, *The Omnibus,* 1892

Miss Violet Sargent. The case beneath these paintings is dedicated to Gardner's extensive correspondence with Matthew Stewart Prichard, an art historian and arts administrator, as well as letters from the economist Abram Piatt Andrew. Prichard lived in a guest suite on the first floor of the museum, now the Macknight Room, in its earliest years and became one of Gardner's closest confidants; her friendship with Andrew was similarly close, and their conversations were broad in scope, ranging from matters of immigration policy to the war effort during World War I.

In the case directly beneath the window, letters and objects related to Okakura Kakuzo appear alongside other mementoes of Gardner's friendships

and interests, including photographic portraits of Jewett, the historian George Bancroft, and the poet Walt Whitman. An original manuscript by Ralph Waldo Emerson and a lock of Nathaniel Hawthorne's hair are placed to the far right of the case, revealing Gardner's great interest in the writers of the American Renaissance. A third case, to the right, holds letters from Berenson as well as notes from the poet T. S. Eliot and a photograph of the social reformer Julia Ward Howe, all of whom were friends of Gardner. Directly above Howe's photograph is Zorn's *The Omnibus,* a work Gardner purchased from the artist when they met at the World's Columbian Exposition in Chicago in 1893. Because Howe was an active proponent of women's independent travel in the late nineteenth century, Gardner's positioning of this painting—which depicts unchaperoned women commuting in Paris—would appear to be an intentionally thematic pairing in the interest of women's emancipation.

The alcove to the right of the northern wall displays equally recognizable works by artists in Gardner's circle, but works by lesser-known artists are also included. Jan Voerman's *Nasturtiums* hangs to the left of the alcove, the gold and vermilion flowers resplendent against the cobalt and gray pots from which they bloom. Gardner displayed trailing vines of nasturtiums from the third-story windows that lined the courtyard, a tradition the museum has continued to honor each year around her birthday on April 14. Sargent's *Madame Gautreau Drinking a Toast* is close by and shows the subject of the artist's infamous portrait *Madame X* (The Metropolitan Museum of Art, New York). This early study of Gautreau shows Sargent's efforts to capture her distinctive complexion on the canvas, and the violet pallor of her skin suffuses every part of the painting, from the table's floral centerpiece to her gauzy décolleté. Also nearby is La Farge's remarkable study of a group of South Pacific islanders, *A Samoan Dance,* created during the artist's journey through the South Pacific with the historian Henry Adams, who was also a friend of Gardner's. To the right of the window, a small portrait of Henry James by his nephew William James, Jr., appears beneath her friend Howard Cushing's tribute to his wife, *A Shower of Gold.*

Along the eastern wall of the Blue Room, a desk set with an English silver tea tray with teapot, a French faience inkstand, a Dutch brass tobacco box, and a Russian tray depicting the Adoration of the Magi stands beneath Sargent's *Yoho Falls.* To the upper left of the wall behind the desk hangs Jean Baptiste Camille Corot's *Noonday* and to the right Sargent's study *Astarte* for the mural *Triumph of Religion* at the Boston Public Library. Desks adorned with historic writing utensils, curios, and other objets d'art appear throughout the galleries of the museum like small stage settings, inviting visitors to contemplate the work habits and enthusiasms of the person who might sit there.

Books from the Vatichino

VATICHINO

When Gardner undertook a renovation and expansion of gallery spaces in
the museum between 1914 and 1915, she created a small gallery on the first floor
between the central hallway and the newly created Macknight Room. She
playfully called this narrow room "the Vatichino"—the little Vatican—because,
in the words of her biographer Morris Carter, "the space was so limited and so
crowded." As she did in the Yellow and Blue Rooms, Gardner displayed fine art,
furniture, books, and a range of archival objects in this gallery, which was
occasionally open to visitors in her lifetime.

After 1972 the gallery served as a coatroom for the newly anointed exit to
the museum. Now, the Renzo Piano wing serves as the entrance to the historic
building and the Vatichino has been renovated and reopened as a gallery space.

MACKNIGHT ROOM

As the only room in Gardner's museum to be named after a contemporary artist,
the Macknight Room pays tribute to the work of Dodge Macknight, whose
watercolors ring the gallery. Before 1915 this room served as an apartment for
Gardner's personal guests—including Sargent, Okakura Kakuzo, and Prichard,
whose portrait by John Briggs Potter hangs on the northern wall of the gallery
above the desk. It later became her personal reception room. As is the case with
the Yellow and Blue Rooms, the Macknight Room is a gallery largely devoted to
the display of works by Gardner's close friends and associates. It also contains a
selection of her important book collection. With its whitewashed walls and com-
fortable arrangements of handpainted or overstuffed furniture, the Macknight
Room conveys an informal and welcoming atmosphere for today's visitors.

Paul Manship's bronze sculpture *Diana* sits atop an eighteenth-century Venetian side table and is reflected in a mirror from the same era just behind it. The goddess appears in midair, with an equally nimble hound beneath her. This unabashed display of feminine athleticism would have appealed to Gardner, who was an accomplished dancer and a reportedly gifted sprinter, and who kept news clippings related to both men's and women's sporting achievements. Although the Macknight Room is named for a male artist whose artistic standing and reputation Gardner sought to promote, the gallery also features works of art by women in Gardner's circle. On the bookcases to the right of the doorway to the Vatichino and directly across from the statue of Diana, Anna Coleman Ladd's bronze bust of Maria de Acosta Sargent shows a similarly well-modeled young woman before another Venetian mirror. Ladd was an artist who worked with the Red Cross during World War I, using her skills in metalwork to craft hand-made facial prosthetics for soldiers disfigured on the battlefield. Gardner was active in relief efforts during the war, and she undoubtedly admired Ladd's rehabilitative efforts. To the left of the bookshelf is the pastel drawing *Gladioli* by Sarah Choate Sears, a Boston-area artist whose photographic portraits of Berenson, Loeffler, and Sargent were also collected by Gardner.

Numerous portraits and landscape paintings reinforce the contemporary nature of the collections in the Macknight Room. Above the bookcase and to the left of the aforementioned bronze by Ladd is Sargent's last portrait of Gardner, the watercolor *Mrs. Gardner in White* from 1922. This moving portrait portrays Gardner—who was at this point paralyzed by a stroke that had occurred in 1919—as a transcendent figure, her limbs cocooned in layers of white fabric that drape her face and body. Her face is youthful because of the clarity of her blue-eyed gaze, which seems at once gentle and dispassionate. To the right of the Ladd bust is a charcoal portrait by Sargent of Thomas Whittemore, the scholar and preservationist who gave Gardner several of her works by Matisse. In addition to these intimate portraits, a number of works by Louis Kronberg, including several studies of ballet dancers, appear on the southern and eastern walls of this gallery. Degas's chalk and pastel drawing *A Ballerina* appears to the immediate right of the doorway leading to the court-yard as well, reminiscent of Gardner's own love of dancing.

The volumes in a bookcase on the eastern wall—ranging in date from the seventeenth to the twentieth centuries—reflect Gardner's wide-ranging interest in history and literature, and also highlight the contemporary authors she counted among her friends. Other important books include James Boswell's *The Life of Samuel Johnson*, works by Jonathan Swift, editions of Plutarch's *Lives*, the col-lected writing of Friedrich Schiller, the *Fables* of Jean de La Fontaine, and William Blake's *Illustrations of the Book of Job.* An original manuscript by Longfellow, "The

Macknight Room with Paul Manship's *Diana*, 1921

Atlantic Souvenir," is also in this case, as are works by other nineteenth-century authors, including Robert Browning's *The Ring and the Book* and the collected writings of Leo Tolstoy. The bookcase also houses many works by contemporary poets and playwrights known to Gardner through her extensive social networks, including the Irish authors Lady Augusta Gregory, William Butler Yeats, and John Millington Synge. Gardner took a particular interest in Gregory's work as the founder of the Abbey Theatre in Dublin and in 1911 arranged for the dramatist to lecture at the museum on national theater and censorship.

Edgar Degas, *A Ballerina,* about 1880

Gardner's Venetian writing desk stands along the northern wall of the Macknight Room and holds a number of her writing utensils and other personal effects. Many objects that Gardner stored within its drawers and cabinets remain there, including cartouches in a rudimentary wooden box lined with cotton wool from her travels in Egypt during the 1870s; ivory miniatures of Indian courtiers wrapped in tissue paper; and a collection of rocks that might have been gathered from one of the family's beach properties in Massachusetts or Maine.

Above and around the desk are works that recall Gardner's interests in both man-made and natural environments at home and abroad. Ralph Curtis's watercolor *A Japanese Tea-House* portrays an idyllic teahouse set on stilts above the water, its leafy arbors hung with white and red lanterns that float above the house's patrons. Wilton Lockwood's *Peonies* flush pinkly against the dark background of the canvas, while Dennis Miller Bunker's pastel *Moonrise* reveals a landscape softened by twilight, a golden moon rising above rounded hills through which a solitary figure paces. To the far left of the desk on the angled wall in the northwest corner, Elizabeth Wentworth Roberts's *The River at Concord* shows the gentle colors of early spring in New England, the trees violet with new buds and the dry grass golden before a rambling white clapboard house along the riverbank.

Of course, the Macknight Room is also home to a great number of water-color paintings by its namesake. Gardner was selective in her patronage, but she enjoyed promoting the work of artists whom she considered to be rising stars nearly as much as she loved acquiring masterpieces ahead of the marketplace. Gardner purchased nearly a dozen works by his hand and displayed them in this gallery, including *A Road in Winter, Cape Cod* and *Towering Castles, Grand Canyon.* While Gardner acquired few studies of the American West, she did travel extensively in the Southwest and California in the 1880s, and Macknight's travel sketch undoubtedly appealed to her memory of those dramatic land-scapes, so unlike the mild byways and tame hillocks of New England.

WORTHINGTON STREET LOBBY

The door on Worthington Street (now Palace Road) was Isabella Stewart Gardner's personal entrance, through which she accessed her private residence on the museum's top floor. Chinese and Japanese wood carvings, one featuring two rabbits sitting in a glade, surround the lobby. Three flower-pickers mounted in a cane rack invite us to imagine Gardner heading out the door to gather roses from her garden. Each sticklike pair of scissors is operated by a trigger, enabling the user to snip blossoms while avoiding thorns.

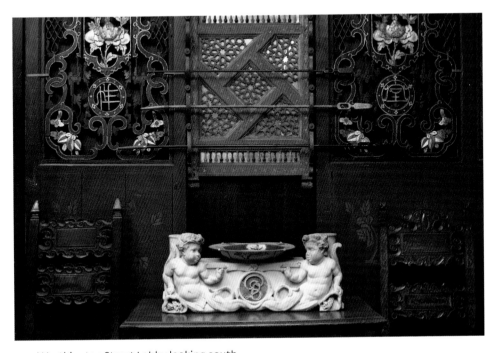

Worthington Street Lobby looking south

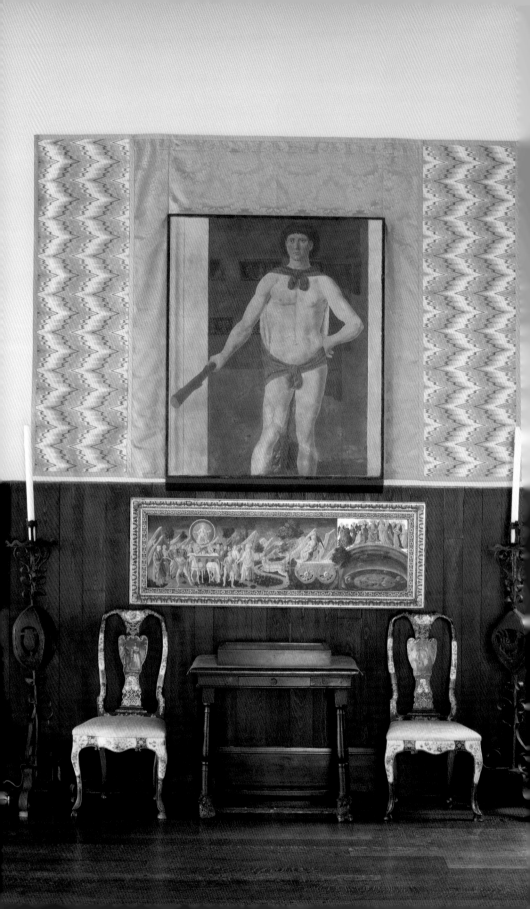

SECOND FLOOR

EARLY ITALIAN ROOM

Gardner traveled all over the world but visited Italy more often than any other country, and this room takes its name from the collection of Italian Gothic and Renaissance paintings that line its walls. To set the scene, she framed the entrance with a magnificent portal, the inner front door of the Borgherini Palace in Florence, which was probably designed by the architect Baccio d'Agnolo in the sixteenth century. Delicate inlays decorate its frame, including tiny harpylike creatures and swirling vines.

Piero della Francesca's giant *Hercules* presides over the entire space. Carrying a wooden club in his right hand, the triumphant hero wears the fuzzy pelt of the defeated Nemean Lion, tied casually at his neck and waist. Piero painted *Hercules* in fresco (tempera paint on wet plaster that locks in the colors as it dries) on the wall of his family palace in his hometown of Sansepolcro in about 1470. Located above the door in his private apartment, it hinted at the painter's social ambitions just as here it reflects the aspiration of Gardner for her collection.

Gardner's free mixing of artworks representing both sacred and secular subject matter emerges clearly in this corner, where the fearsome warrior Hercules hangs adjacent to Bicci di Lorenzo's monumental *Annunciation*. Below them are three jewel-like paintings of devotional narrative scenes from

Early Italian Room with Piero della Francesca's *Hercules*, about 1470

Early 16th-century Florentine doorway to the Early Italian Room

northern Italy, whose cities were a hotbed of creative talent during the Renaissance. From left to right they are *The Circumcision of Christ* by Cosmè Tura, *The Death of the Virgin* by Antonio Cicognara, and *The Virgin and Child with Infant Saint John the Baptist and Six Female Saints* by Andrea Mantegna. Tura worked for the court of Ferrara, Cicognara in Cremona, and Mantegna in Mantua for the Gonzaga family. The latter was one of the favorite painters of Isabella d'Este, the marchioness of Mantua, perhaps the most celebrated female patron in European history and a collector idolized by Gardner. Like her Renaissance heroine, Gardner worked with many agents who helped her to find

Andrea Mantegna, *The Virgin and Child with Infant Saint John the Baptist and Six Female Saints,* about 1497–1500

works to purchase. She acquired Mantegna's panel through the archaeologist Richard Norton.

Flanking the doorway to the Raphael Room are two long, horizontal paintings by Pesellino (the Little Pea), one of the most talented painters in mid-fifteenth-century Florence. He worked for the Medici and Pope Nicholas V. Very few of his works survive today, but Gardner bought three, more than any other American collector. To the left is Pesellino's *Triumphs of Love, Chastity, and Death,* and to the right is his *Triumphs of Fame, Time, and Eternity.* Inspired by Petrarch's *Triumphs,* one of the most popular poems in Renaissance Italy, Pesellino envisions the allegories as a street parade set in a landscape. Fame sits atop a cart pulled by two horses and surrounded by

Following pages: Early Italian Room with Simone Martini's *Virgin and Child with Saints,* about 1320; Francesco Pesellino's *Triumphs of Love, Chastity, and Death,* about 1450; Gentile Bellini's *Seated Scribe,* 1479–81

Gentile Bellini, *Seated Scribe*, 1479–81

worthies including Dante and Virgil. The rectangular shape of both paintings reflects their original function as the fronts of a pair of wedding chests (*cassoni*). Often decorated with mythological, allegorical, or moralizing scenes, they held the bride's trousseau, which was carried to the home of her future husband and typically installed in the bedroom.

To the left of the door to the Raphael Room are two of the most important works in Gardner's collection. Resting on the desk, in a compact case, is the small *Seated Scribe*. In 1479 Gentile Bellini, the state painter of Venice, traveled to Constantinople, took up residence at the court of Mehmet II, sultan of the Ottoman Empire, and drew several of the ruler's courtiers. Few of these portraits survive, and only this sheet is finished with color and gold, adding realistic polish to details like the crushed red velvet of the scribe's thick sleeves. Arabic text in the upper right corner is a later addition, probably penned when this drawing arrived at the royal court in Persia and was mounted in an album for the shah's youngest son.

Early Italian Room with Niccolò di Pietro Gerini's *Saint Anthony Abbot with Four Angels*, about 1380; and Ambrogio Lorenzetti's *Saint Elizabeth of Hungary,* about 1319–47

An altarpiece by the Sienese master Simone Martini glistens above the little scribe. Martini brought a goldsmith's precision to his handling of detail, as is evident in the meticulous punchwork of each figure's embossed halo. A friend of the writer Petrarch, Martini was celebrated in his own time as a modern-day Apelles and worked for both the city governors of Siena and the pope's court at Avignon. He painted this polyptych—an altarpiece with multiple panels—for the church of Santa Maria dei Serviti in the central Italian hill city of Orvieto. It depicts the Virgin and Child flanked by Saints Paul, Lucy, Catherine of Alexandria, and John the Baptist. The latter's wildly disheveled hair attests to a life spent in the wilderness. Above, small triangular pinnacles frame four angels, two of whom blow trumpets while the remaining pair holds symbols of Christ's Passion—the crown of thorns, cross, three nails, whip, and column against which he was flagellated. Christ, bearing the stigmata on his hands, stands atop the central panel.

Gold grounds unite the remaining paintings in this room. The largest of them is Niccolò di Pietro Gerini's monumental *Saint Anthony Abbot with Four Angels.* With his staff in one hand and an orange book in the other, the founder of Western monasticism sits enthroned among angels, who unfold an iridescent cloth of honor behind him. The blue hooded robe beneath Anthony's black cloak suggests that this painting may have come from a church of Antonite Hospitallers, a religious order who established hospitals in their patron saint's name across Europe.

Practically hidden among the other glittering images, next to a window on the far side of the chimney, is a Renaissance masterpiece. Even though Fra Angelico painted *The Dormition and Assumption of the Virgin* in Florence more than five hundred years ago, each figure bursts with color. At the bottom, the apostles prepare the Virgin Mary's funeral bier. Christ stands in the center, holding her soul, depicted as a small child, in his arms. In the upper register, the Virgin ascends amid a spinning vortex of angels who clasp hands and enact a lively dance that propels her into heaven and the outstretched arms of God the Father. This small painting was originally one of a set of four reliquaries, containers for holy relics. They were painted for the Florentine church of Santa Maria Novella and each depicts episodes from the Virgin Mary's life.

Several works of art throughout the museum memorialize events of special importance to Gardner, including Ambrogio Lorenzetti's tiny *Saint Elizabeth of Hungary.* Enshrined by a blue silk chausable (a liturgical garment) and several candlesticks, Gardner's altarlike installation commemorates the death of Victor Emmanuel Chapman, a soldier who died in World War I and whose parents sent this painting to the museum as a gift in his memory.

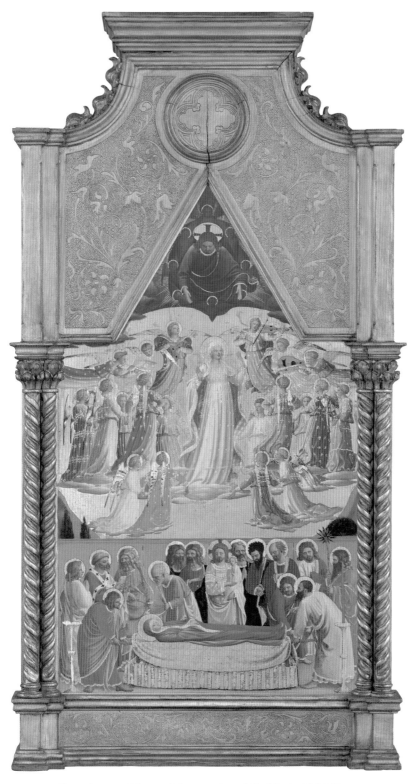

Fra Angelico, *The Dormition and Assumption of the Virgin,* 1430–34

Japanese, *Roof Tile: Dove,* 19th century

Time and again Gardner juxtaposed modern design with old masters. A good example of this practice is a beech sofa table by the legendary New York designer Elsie de Wolfe that Gardner transformed into a silk-covered altar for her sparkling tabernacle by the fourteenth-century Sienese painter Bartolomeo Bulgarini. Unlike other society grandes dames, Gardner was not de Wolfe's client, but she did support female professionals, and the two New Yorkers forged a friendship based on their shared love of beauty. De Wolfe declared in a newspaper article that Gardner had no equal in America. She made a final visit to the museum near the time of Isabella's death, comparing her host's pallid appearance to "primitive pictures of saints."

Like many rooms in the museum, this one displays a wider range of material than its name suggests, including vestiges of its former life as the "Chinese Room." From the opening of the museum until the renovations of 1913, this space was a shrine to China and Japan. The glass case on the west wall contains Chinese, Korean, Egyptian, and Persian works of art. Even more surprising is the Japanese roof tile in the shape of a dove that can be seen through the window into the courtyard; it watches over visitors like the pigeons in Piazza San Marco in Venice.

Bartolomeo Bulgarini's *The Virgin Enthroned with Saints and Angels,* about 1355–60, above Elsie de Wolfe's *Sofa Table,* early 20th century

Following pages: Raphael Room looking southeast

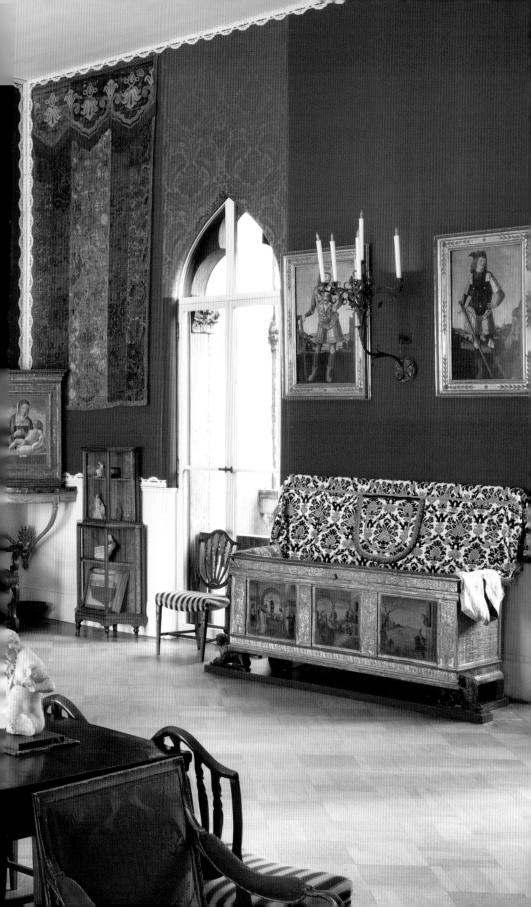

Raphael, *Lamentation over the Dead Christ,* about 1503–5

RAPHAEL ROOM

Named after the celebrated Renaissance painter, this room commemorates that moment when Italian artists looked to ancient Greece and Rome for inspiration. Brightly colored paintings from Florence, Venice, and Rome hang against rich red fabrics, setting an opulent tone. The heavy wall covering is not cut from a single bolt of damask but is a patchwork of boldly patterned fragments sewn together and stretched across the walls. Chairs upholstered in red, yellow, and

Raphael, *Count Tommaso Inghirami,* about 1515–16

green silk chime in at the center of the room. Two massive velvet amorials hang from iron rods, flanking the Venetian-style fireplace.

One of Gardner's greatest triumphs is Raphael's portrait *Count Tommaso Inghirami.* She bought it in 1898, and it became the first painting by Raphael to be brought to the United States. It was a major coup. According to Henry James, Raphael's work was "semi-sacred," and all the more so for its scarcity. Many American collectors tried and failed to find authentic examples in a

market flooded with copies, but Gardner ultimately acquired three. Inghirami wears the scarlet cap and tunic of secretary of the college of cardinals (to which he was nominated by Pope Julius II in 1504). Rings on his right hand convey wealth and status. In 1505 he was appointed head of the Vatican library by Pope Julius II, Raphael's most powerful patron. The painter captures the corpulent scholar in a moment of contemplation. He sits pen in hand and prepares to copy from an open book into a quire (gathering of sheets of paper). Inghirami occupies an office fit for a prince of letters. Decorative wood inlay frames the edges of his desk. Bound in red leather, the manuscript, sporting tiny gold clasps, rests on a beautifully carved box with circular red feet. But the papal court painter did not let flattery get the better of verisimilitude. Raphael positioned the pope's librarian looking up and to the right, perhaps for divine inspiration but also at an angle that cleverly downplays his lazy eye.

Gardner purchased a second work by Raphael two years later and installed it just below the first. Much smaller in scale, *Lamentation over the Dead Christ* sits atop a desk with a chair placed before it, drawing greater attention to this jewel-like painting. A gathering of mourners surrounds Christ's body. Bearing the wounds of the Passion, his lifeless form lies in his mother's lap, supported by John the Evangelist and adored by Mary Magdalene, who kisses Christ's feet. A luminous blue landscape recedes into the distance. This tiny painting is a fragment of a much larger complex. Between 1503 and 1505 Raphael painted a monumental altarpiece for the Franciscan nuns at the church of Sant'Antonio in the Italian hill city of Perugia. Two centuries later, they sold it in pieces, and the parts began to be dispersed into private collections. Not long after Gardner's acquisition, the American financier J. P. Morgan bought the main panel for the record-breaking sum of $400,000. The Boston collector got hers for the comparative bargain price of $24,577.

Just to the right of this panel is one of the collection's most dramatic paintings, *Saint George Slaying the Dragon* by Carlo Crivelli. The artist compressed the story of this heroic deed into a single action-packed moment. Run through with a lance, the monster roars in agony, frightening the saint's steed. His horse rears and shies away, eyes wide with terror. In a feat of remarkable horsemanship, George stands up in his stirrups, drops the reins, and draws his sword high to deliver the death blow. All of this action plays out in the immediate foreground while in the background the princess prays for her salvation and that of her city. Like the Raphael, this painting was once part of a towering altarpiece. It consisted of six panels, with this one on the right, celebrating the patron saint of the city. *Pastiglia*—sculpted plaster features—enliven the saint's armor and the horse's reins.

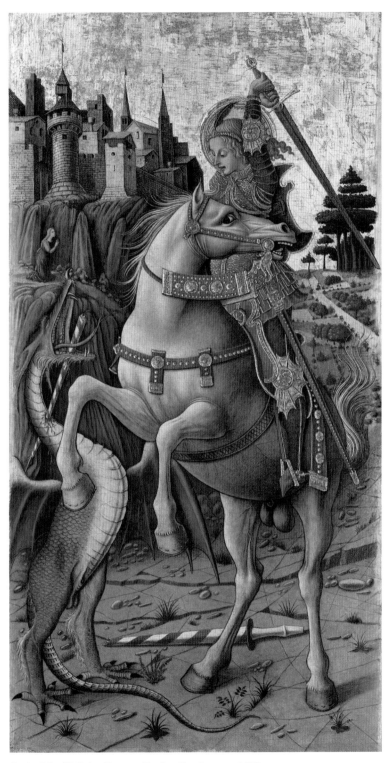

Carlo Crivelli, *Saint George Slaying the Dragon,* 1470

Sandro Botticelli, *The Tragedy of Lucretia,* 1499–1500

To the right of the door on the east wall is *The Tragedy of Lucretia,* painted by Sandro Botticelli around 1500. Tall buildings inspired by the remains of Roman antiquity frame a grand piazza. In the shadow of a stately triumphal arch, soldiers throng to the woman lying dead at the base of a column. She is the heroine Lucretia, and her story sets in motion a series of events leading to the establishment of Rome as a republic. It begins at the far left. As his servant waits in the foreground, Prince Tarquin attacks Lucretia in her own house. Because she refuses to submit, he threatens to kill her and make the death look as if she was raped by his servant, thus bringing further dishonor to Lucretia's family. She unwillingly accedes to Tarquin. When her family returns, she describes the rape to them and collapses in grief. Determined to avenge the clan's dishonor, Lucretia commits suicide with a dagger. In Botticelli's painting

her body lies at the base of a column supporting a statue of David standing over the head of Goliath, a symbol of liberty from tyranny. Her father and husband rally soldiers in its shadow, determined to avenge the injustice and overthrow the corrupt house of Tarquin.

With the installation of her first Botticelli, Gardner evoked the interior of a Renaissance palace. The richest citizens of fifteenth-century Florence commissioned sets of horizontal narrative paintings (*spalliera*) like this one for display at shoulder height in bedchambers or reception rooms. Depicting moralizing and mythological scenes, they were often paired with *cassoni* painted with similar subjects. Gardner staged one such ensemble here. In 1894 she bought both the

Following pages: Raphael Room looking west

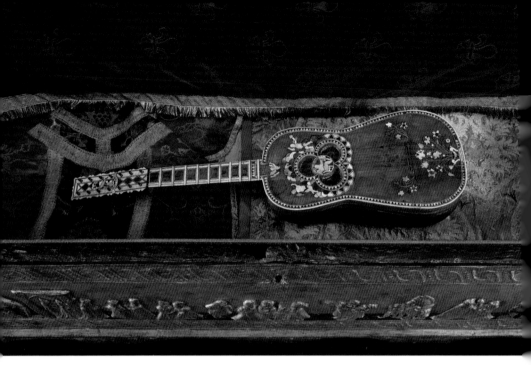

Jacopo Mosca Cavelli, *Guitar*, 1720s

Botticelli spalliera and the chest that appears beneath it, installing them together at her house on Beacon Street and subsequently replicating the arrangement at the museum. *The Tragedy of Lucretia* appears at eye level above the chest, which shows a procession of figures sculpted in plaster and gilded—like the Crivelli.

With their velvet draped tops open, the chests in this room invite you to peer inside. Lying in one is an elegant eighteenth-century guitar, with inlaid mother-of-pearl cupids and bone frets, carved by an instrument maker from the Adriatic port city of Pesaro. A similar spalliera/cassoni arrangement appears against the wall facing the Courtyard, with two elegantly dressed heroes from antiquity above, painted as part of a series, probably in Siena by Neroccio di Bartolommeo de' Landi. Gardner also used the surviving fronts of two chests as decorative paneling for the wall on the opposite side of the room. The one on the right features a repeating pattern of seated leopards, and on the left many armed warriors engage in an ancient battle and procession.

Ancient Rome plays a starring role in this room, as it did in the High Renaissance. In the late fifteenth and early sixteenth centuries, rich patrons sought to create a new golden age through the revival of antiquity. Their artists looked for inspiration to the surviving remnants of Roman art, including wall paintings, sarcophagi, and vases. Two fragments of ancient wall paintings can be found at the bottom of the small case beneath the Virgin and Child by Giovanni Bellini. One of the most surprising examples of ancient sculpture in this room is the elaborately shaped third-century BC terracotta vase found in

southern Italy. Figures of the goddess Nike tower over the leaping horses and the face of the mythological monster Medusa.

Gardner created many meaningful juxtapositions with her installations, bringing works of art into dialogue with one another. One of the most visually striking but underappreciated sculptures stands atop a cabinet. The highly polished marble foot resonates with the *Virgin and Child* (attributed to the studio of Cima da Conegliano). She holds her son and caresses his foot with her left hand. This painting and another, a profile portrait of a woman attributed to the Florentine artist Piero del Pollaiuolo, flank a large *Annunciation* by Piermatteo d'Amelia. That the Virgin Mary appears twice on this wall with the portrait perhaps emphasizes her role as a model for Renaissance women.

Several Renaissance paintings of devotional subjects line the walls flanking the door on the west side. The most spectacular is the central painting depicting the Virgin Mary kneeling before Gabriel in her lavish house, cast as an Italian Renaissance palace. The archangel announces to the Virgin that she will bear the son of God. Painted about 1487, it served as the high altarpiece of the church dedicated to the Annunciate Virgin outside Amelia, the hometown of the artist Piermatteo d'Amelia. Although he is little known today, Piermatteo made his reputation in Rome, working for several popes and submitting a design for the Sistine Chapel ceiling before Michelangelo. Gardner recognized the beauty of this Annunciation and acquired it through Bernard Berenson and his fiancée, Mary Costelloe, in 1899. To avoid extortionate export taxes, the Berensons smuggled it out of the country in the false bottom of a chest packed with children's dolls.

SHORT GALLERY

In contrast to the grandeur of many of the other galleries on the second and third floors of the museum, the Short Gallery offers an informal environment for viewing Gardner's collection of prints and old master drawings, as well as a selection of books, textiles, and family portraits. Visitors entering from the Raphael Room pass through a gilded Rococo doorway and enter a narrow gallery stretching to the right and left, with doorways to the Little Salon and the Tapestry Room located on the eastern and southern sides of the room. Like the galleries on the first floor of the museum, the Short Gallery incorporates many items of a personal nature alongside Gardner's book collection, as well as many works of art contemporary to her era.

To the left and right of the doorway to the Raphael Room are cases holding a number of Italian textiles from the fifteenth and sixteenth centuries, as well as other handmade clothing. Gardner took a great interest in historical textiles and acquired an extensive collection of lace, liturgical and ceremonial

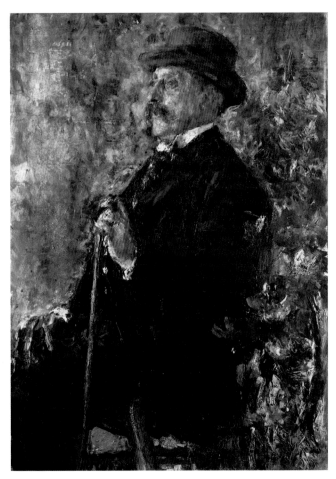

Antonio Mancini, *John Lowell Gardner, Jr.,* 1895

attire, and yardage for use throughout her museum. Beyond these, a number of
Stewart and Gardner family portraits are hung around the northern end of the
Short Gallery, as well as two portraits of Isabella herself. A portrait of her
great-grandmother Mary Brough Stewart is displayed above the case holding
textiles to the right of the doorway, while Martin Mower's *Isabella Stewart
Gardner* and a portrait of her grandmother by Thomas Sully, *Isabella Tod Stewart,*
hang to the right. Antonio Mancini's *John Lowell Gardner, Jr.* can be seen to
the left of Anders Zorn's resplendent portrait *Isabella Stewart Gardner in Venice.*
In an apparent allusion to the couple's many happy seasons along the waterways
of Venice, Gardner placed Vittore Carpaccio's *A Gondolier* on a stand beneath
these portraits and hung John Ruskin's architectural study *The Casa Loredan,
Venice* to their right. Several smaller portraits appear to the right of the Zorn
portrait, including one of her nephew William Amory Gardner by William
Morris Hunt and portraits of both George Washington and Benjamin Franklin.

Short Gallery looking south

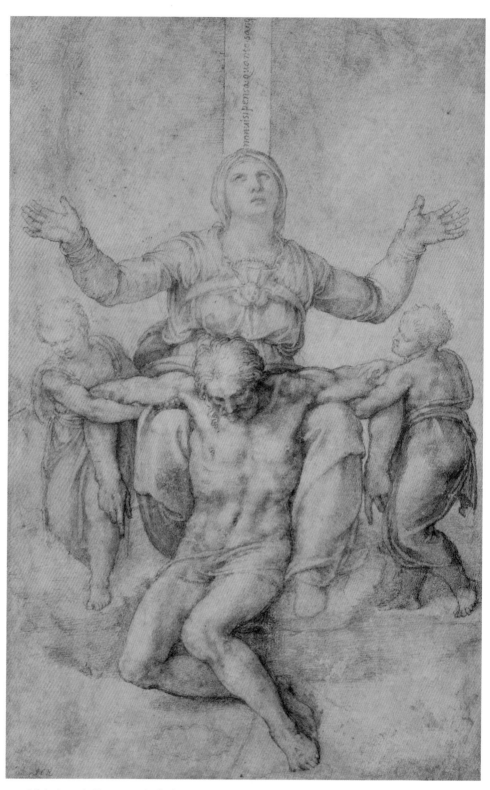

Michelangelo Buonarroti, *Pietà*, 1540

The familial nature of most of these portraits lends an autobiographical feeling to Gardner's installation of the Short Gallery, a sentiment reinforced by the inclusion of a tall secretary-bookcase (eighteenth century) holding the published works of her friends, including Berenson and the artist John La Farge.

The most significant works of art in the Short Gallery appear in the large cupboards that line the south side of the eastern wall. These cabinets were designed by Gardner to accommodate her small but distinguished collection of prints and drawings. Several old master drawings are displayed in the far left side of the cabinets, including the *Pietà* drawn by Michelangelo Buonarroti in 1540 for his friend Vittoria Colonna, an accomplished poet of the sixteenth century. Other highlights of the collection include the *Procession of Pope Sylvester I* by Raphael and *Study for a Figure in the Resurrection* by Agnolo Bronzino, the former an extremely rare work by the artist, executed in colored chalk. Gardner drew great satisfaction from acquiring works from the estates of prominent collectors, and all three of these master drawings were purchased at auction from the estate of Sir John Charles Robinson, a collector, scholar, and curator who was instrumental in forming the South Kensington Museum (later the Victoria & Albert Museum) in London. Perhaps to demonstrate her own collecting acumen in the realm of contemporary art, Gardner dedicated much of the right side of the cabinets to prints by her friends Whistler and Zorn, intermingled with works by Henri Matisse, Leon Bakst, and other modern artists.

LITTLE SALON

Conjured by Isabella Stewart Gardner, this fanciful space epitomizes the internationalism of the Rococo, uniting French painting, Italian furnishings, and German sculpture. Figures of cupids dance on frames, and vines twist their way through door frames and around paintings. Based on a conflation of the French words *rocaille* and *coquillage* (the rock and shell work that decorated fountains and grottoes in gardens), the Rococo style emerged in the decorative arts of eighteenth-century France. It is characterized by delicate patterns based on shells, plants, and vines that draw attention to the work's surface and paintings that celebrate the pursuit of pleasure in pastel colors. Rococo splendor caught on at the French royal court and spread across the Continent, establishing itself as the visual language of the European aristocracy. It may have appealed to Gardner for these very reasons.

Vines entangle the room. Winding along the edge of the floor-to-ceiling mirror that Gardner acquired in 1897 with a suite of furnishings from the Palazzo Morosini in Campo Santo Stefano, Venice, they lend a lighthearted

Following pages: Little Salon looking northeast

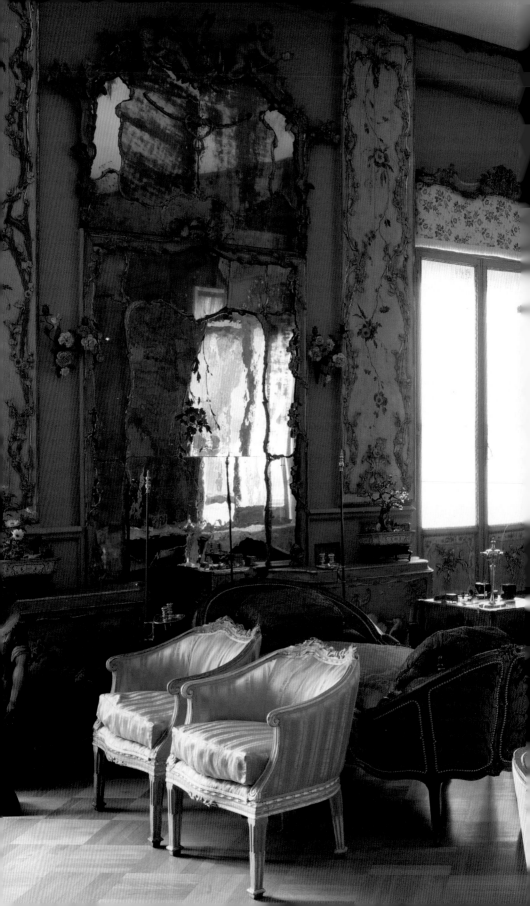

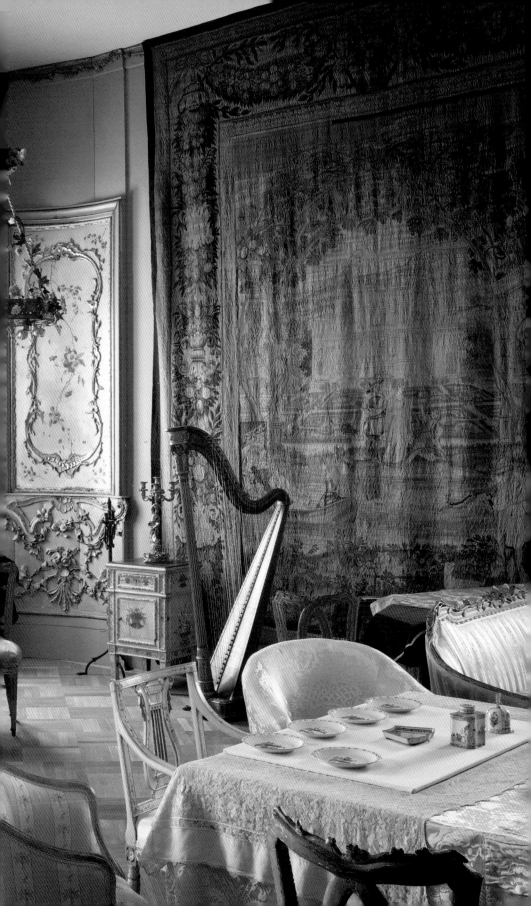

touch and appear to peel back from the wall as the mirror's panes reach the ceiling. Putti or cupids carved entirely in the round cavort along the summit—one blowing a horn and the other waving a victory plaque—as if they were inhabitants of a different world, somewhere between the architecture and its furnishings. Foliage appears to flourish in the same zone, sprouting up behind a Morosini coat of arms. The aristocratic Morosini possessed several palaces, but only the furnishings of this one celebrated a heroic ancestor, the doge (ruler) of Venice, who led a series of naval victories over the Ottoman Empire, heralded by the pair of putti above. At the Gardner, the Rococo wall panels set a more playful tone. Gardner did not simply reproduce the installation of an eighteenth-century Venetian palace. Instead, she creatively adapted the Morosini suite to her needs—for example, by repurposing rounded corner panels as fancifully monumental framing devices flanking the mirror and, more drastically, breaking up a bed into a pair of benches.

Similar themes continue into the works of art on either side of the entrance door. The mirror's pair of ecstatic putti appear to have landed on paintings filled with friends. The figures in *Three Cupids* play with bows and arrows in a frame reconstructed from Morosini paneling, and to the right they surround *The Chariot of Venus* by the French court painter François Boucher. Here the pudgy sprites tumble through the sky bearing flowers and torches, symbolizing the victories of the heart for the goddess of love. In 1902 Gardner's trusted friend and adviser Ralph Curtis alerted her to the availability of this painting in a letter that begins, "Hail, dear Queen!" a salutation appropriate not only to the Queen of Fenway Court but also to the painter himself, as Boucher's first royal commission was for Queen Marie Leszcyaska. Boucher pioneered the Rococo style in the service of King Louis XV, designing motifs for a variety of decorative arts objects. Gardner installed below it an example of the other medium in which he excelled, tapestry. This framed fragment, *Amorino Offering Flowers to a Sleeping Nymph,* is in the style of Boucher.

Gardner's taste for French art and the pursuit of pleasure extends to the tapestries. Lavish floor-to-ceiling scenes of pleasure gardens and stately châteaux fill the walls like windows onto a fairy tale. The Baroque tapestries are part of a set of four (two Flemish and two French) owned by Cardinal Antonio Barberini that possibly decorated his Paris residence.

Smaller-scale objects and cases contribute to the intimacy of this space. A splendidly gilded corner case bursts with Meissen, the hard-paste porcelain made near Dresden that was adored by German and French nobility. Cupids have landed here, too. They surround a shepherdess and alight on the frame of

Venetian, *Mirror from the Palazzo Morosini,* 1760–80

François Boucher, *The Chariot of Venus,* 18th century

an elaborate mirror, part of a larger ensemble that includes two yellow birds. The shelf below features a miniature portrait of Marie Antoinette, the wife of King Louis XVI, and another of the mustachioed Polish general Joseph Dwernicki, both of which possibly belonged to the minister of finance under Napoleon. Gardner also kept personal items in these cases. The small red box contains a pair of tintypes depicting herself and her husband, with a miniature painting and photograph memorializing their son, Jackie, and nephew Joseph. A happier remembrance fills a third case. In one tiny locket, Isabella saved a four-leaf clover picked to commemorate the groundbreaking for her museum in 1899.

Of all the rooms in the museum, this one was probably the last to be finalized by Gardner. The Little Salon came into its own in 1914, when she eliminated the Music Room and transformed it into the Spanish Cloister to house

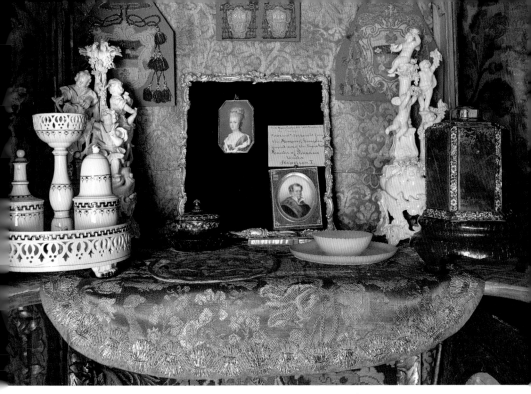

Little Salon with Meissen porcelain and miniature portraits of Marie Antoinette, about 1786, and Joseph Dwernicki, 1833

El Jaleo, in the process enlarging this space by using the balcony of the Music Room. She continued to move works of art into, out of, and around the Little Salon, trying out and fine-tuning its arrangement into its current and final form.

TAPESTRY ROOM

A grand and somewhat mysterious space, the Tapestry Room evokes the pageantry of a great hall in a northern European castle. More dimly lit than other spaces in the museum, the spotlight now shines on the works around its periphery, including imposing tapestries, furniture, architectural fragments at the doorways and windows, and several large paintings, such as the arresting image of Saint Michael at the far end of the room, which hangs over a massive late medieval French fireplace. For decades this painting was the focal point of the room, the backdrop behind a dais where musicians played and lecturers spoke.

Gardner's acquisition of two large tapestry series the very same year that she opened the museum spelled the end of her two-story Music Room. By having a ceiling put in and extending the rooms on the first and second floors, Gardner divided the former Music Room and opened a suite of new spaces to the public in 1914: the Spanish Cloister and Chapel; the Chinese

Following pages: Tapestry Room looking south

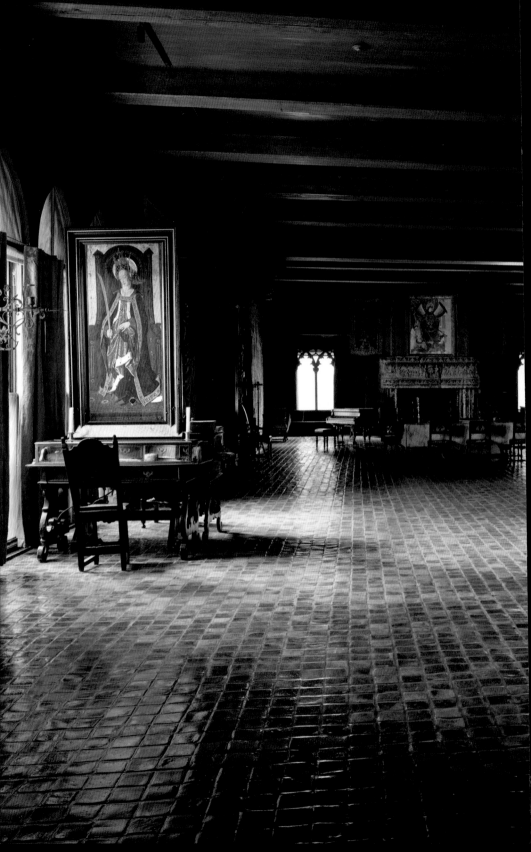

Loggia, including the subterranean former Second Chinese Room; and the Tapestry Room. In so doing, she had created a grand hall to hold ten monumental tapestries.

The ten large Flemish tapestries in the room—showing five scenes from the life of the biblical patriarch Abraham and five scenes from the life of the ancient Persian king Cyrus the Great—came with a distinguished provenance. They may have been commissioned by a Hapsburg ruler in the 1500s and were possibly in the collection of Archduke Albert VII of Austria (1559–1621) and then Archduchess Isabella Clara Eugenia of Spain (1566–1633). Subsequently, they were purchased by Cardinal Francesco Barberini for his Palazzo della Cancelleria in Rome, where they appear in several of his seventeenth-century inventories. In fact, when Gardner bought them, she believed that the Cyrus series actually portrayed scenes from the life of her namesake, Archduchess Isabella Eugenia; a portrait of the archduchess by Frans Pourbus the Younger hangs to the left of the doorway to the central staircase in the adjacent Dutch Room. The most expensive and time-consuming of Renaissance arts, tapestries such as these imparted instantaneous prestige to their owners, something that Gardner and other Gilded Age collectors also appreciated.

Rather than presenting the stories of Abraham and Cyrus chronologically, Gardner divided them up and installed them, interspersed, along three walls of the gallery. The infant Cyrus therefore appears in one corner of the room, being banished to the countryside by his grandfather, who has been told that Cyrus will eventually overthrow him. He next appears as a young man, ready to take his revenge, in the opposite corner of the room.

Cyrus is dressed elegantly in his Renaissance finery, including a brocade-lined cape, platform shoes, and bright red tights, woven from wool dyed with cochineal, one of the most expensive pigments. He makes a sweeping gesture toward the messenger who presents him with a dead hare. Sewn inside the hare is a letter from a general swearing allegiance to the young ruler, urging him to overthrow his grandfather and take control of the ancient Persian Empire. Behind Cyrus, a group of hunters with dogs chases prey in a landscape that evokes the Low Countries of Europe in the mid-sixteenth century, thereby bringing an ancient tale up to the present for its original viewers. A lavish border, with lush foliage and ripe fruit nearly bursting open, frames the scene. In this manner, each of the tapestries in this gallery presents a visual feast; when taken together, they lend an aura of grandeur to the room.

The dramatic, glittering painting *Saint Michael Archangel* manages to hold its own, even among such stiff competition as the commanding tapestries. This prince of heaven, dressed in gold-studded armor and brandishing a spear and a scale to weigh the souls of the elect and the damned, perches on a throne draped

Tapestry Room with French *Fireplace with Courtly Beasts,* about 1338–65; and Pedro García de Benabarre's *Saint Michael Archangel,* about 1470

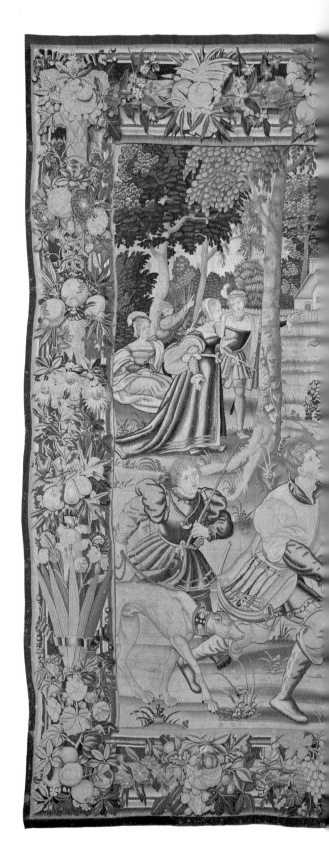

Workshop of Jan Moy, *A Messenger from Harpagos Brings Cyrus a Letter Concealed in a Hare,* about 1535–50

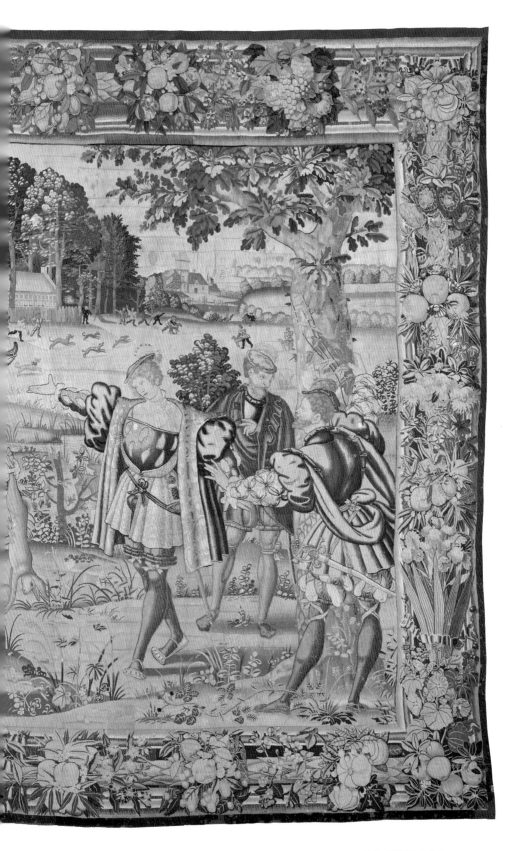

in ornate gold and blue silks. Painted about 1470 by Pedro García de Benabarre, one of the leading Catalan artists of his time, it was originally part of a large altarpiece in the church of San Juan del Mercado, in Lérida, Spain. Benabarre went to great lengths to give this archangel fantastic wings that look like those of a hawk on the inside and those of a peacock on the outside. Equally fantastic is the demon below his feet, who has two faces—one black, with ferocious fangs, and the other one red, in the center of his torso, with comically bulging eyes and a menacing smile. Ahead of her time in acquiring medieval Spanish art, Gardner was offered this painting by a dealer in New York in 1915, just after she had opened the Tapestry Room. When she hesitated, it was quickly purchased by Paul Sachs, the associate director of the Fogg Art Museum at Harvard. She managed to wrestle it from him at a dinner party in this gallery during which, according to legend, she showed him the empty spot above the fireplace and jokingly threatened him with a knife. He acquiesced and sold her the painting.

Another great medieval Spanish painting, a graceful image of Saint Engracia painted in 1474 by Bartolomé Bermejo, came through more conventional means. Gardner had seen and admired it while visiting the Universal Exposition in Paris in 1900 with Curtis. They had both esteemed the masterly painting technique on display in this work, which evokes a range of rich textures, from the grain of woods inlaid in a pattern on the saint's throne to the magnificent woven brocades, furs, and velvets of her clothes. When it came up for sale several years later, Gardner immediately seized the opportunity to buy it. As she did for a number of her favorite paintings, she placed this one near a window, where it would be bathed in warm light and would therefore serve as a focal point during the day. A portrait of Pope Innocent X, by a follower of Diego Velázquez, hangs behind it. Both are set over Italian writing desks from about 1700, with an arrangement of small, personal items. Displayed below the Bermejo are a ledger and small books, a letter opener, a quill, and small silver boxes; a Japanese textile rests immediately behind *Pope Innocent X,* and below it are a number of small Asian objects, including a curled-up stone serpent.

Another deeply personal installation appears across the room, near the windows overlooking the Courtyard. Gardner hung a fifteenth-century icon from Novgorod, Russia, *The Ascension of Christ,* on an easel-like wooden frame; two small lamps hang on either side, as though they could cast perpetual light on the sacred image. As in a traditional Russian home, a decorated cloth with printed and painted tree trunk designs further distinguishes Gardner's version of a domestic altar. Yet this is no ordinary cloth, but a modern silk tabby given

Bartolomé Bermejo, *Saint Engracia,* about 1474

Muhammad ibn Ahmad al-Izmiri, *Leaf from a Copy of the Book of Knowledge of Ingenious Mechanical Devices: The Candle-Clock* by al-Jaziri, 1354

to her by Raymond Duncan, the American craftsman, philosopher, and poet, who was also the younger brother of the acclaimed dancer Isadora Duncan. Raymond, like Isadora, eschewed Western clothing, opting to wear tunics and attire inspired by classical Greece. He corresponded with Isabella and even gave her a book he wrote about Greek vase painting.

A number of other religious items, including a book used for Mass in the Sistine Chapel, appear on a table nearby. Farther down the west wall, six leaves from pages of manuscripts written in Islamic lands, a nod to Gardner's wide bibliographic interests, are shielded from damaging rays of light by cloth

covers that can be lifted. These include three large leaves from a copy of al-Jaziri's *Book of Knowledge of Ingenious Mechanical Devices,* made in Cairo in 1354 by Muhammad ibn Ahmad al-Izmiri, depicting a water clock, a candle clock, and a hydraulic device. Another set of leaves, written in Baghdad in 1224, features medicinal plants and an Arabic translation of Dioscurides's Greek classic *De materia medica.* A nearby table holds an intricate eighteenth-century bookstand from northwest India; an early twentieth-century Iranian wood and lacquer book box; and Gardner's own handwritten catalogue of books. Two chaise longues surround this table, and at one end, near the wall, is a fifteenth-century silver processional cross. At the far end of the table, facing the center of the room, is an Italian Virgin of Mercy candelabrum from 1582; here, the Virgin shelters groups of men and women under her protective cloak. In much the same way, the Tapestry Room shelters under one large umbrella a number of different objects and the many stories they could tell.

DUTCH ROOM

Gardner's taste for northern European art may not have been as legendary as her preference for the Italian Renaissance, but she was no less discerning when acquiring Dutch, German, and English paintings, sculpture, and furniture. In 1896 she purchased Rembrandt's *Self-Portrait, Age 23,* the painting that solidified her decision to transform her private collection into a public museum. This radiant youth with a feather in his cap, staring out from beneath its brim, projects an intense self-confidence. The acquisitions continued during the museum's construction. Charles Eliot Norton described Gardner returning from Brussels in 1899 as "charged with the spoils of the Flemish school," and here we reap the benefit of her conquests. Paintings by Peter Paul Rubens, Jan Gossaert, Giusto Suttermans, Frans Pourbus the Younger, and Antonis Mor join those of Dutch contemporaries to give this room a distinctly non-Italian flavor.

Gardner assembled a magnificent tribute to northern Europe's greatest portraitists. If Rembrandt occupies the place of honor, then the smaller *Man in a Fur Coat* by Albrecht Dürer—possibly painted during the Netherlandish leg of his four-year study tour—makes this wall a rare museum experience: it is one of the only painted portraits by Dürer in the United States. Opposite them hangs a portrait of Isabella Clara Eugenia by Pourbus. The archduchess of Austria addresses visitors with a haughty gaze, and costly silk clothes emphasize her stately bearing. The dress and full-length coat she wears over it, not to mention the spectacular lace collar, endow her with a formal, if uncomfortable, appearance.

Following pages: Dutch Room looking north

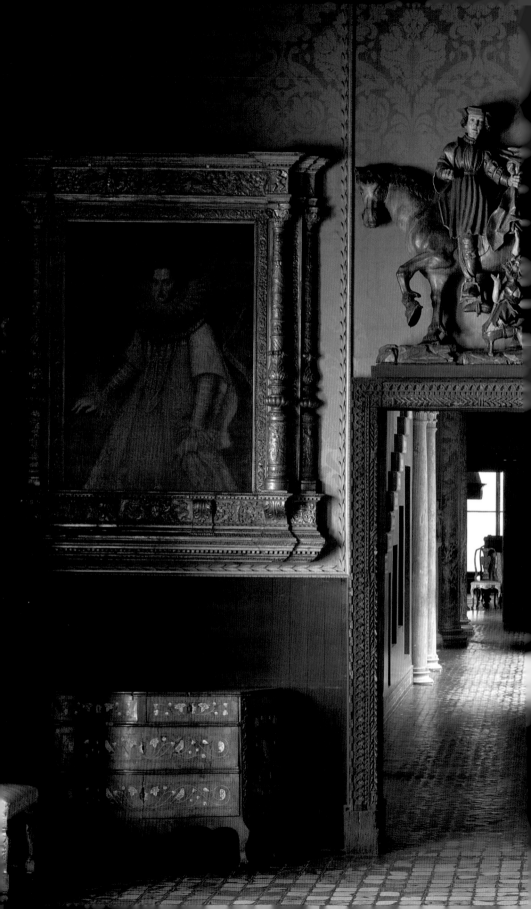

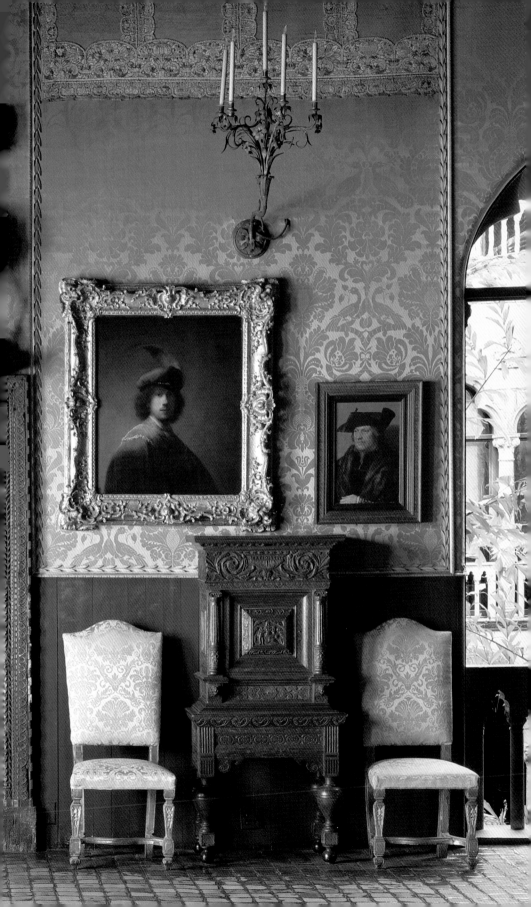

Female rulers throughout history fascinated Gardner, from Hapsburg sovereigns to Isabella d'Este. She installed in the corner across from Isabella Clara Eugenia a portrait of Queen Mary I by Mor. Her father was the English king Henry VIII, portraits of whose physician and his wife (*Sir William Butts* and *Lady Margaret Butts* by Hans Holbein) flank the doorway on the left side of the fireplace. Mary's portrait constituted part of the preparations for her marriage to King Philip II of Spain (who owned the *Europa* in the Titian Room upstairs). Here she wears his engagement gift, the sparkling pendant with a magnificent diamond and pearl. The queen's red velvet throne resonates with a similarly fancy chair beneath the portrait, drawing attention to Mary's royal status and dissolving the boundary between history and the present day.

In the spirit of American democracy, Gardner mixed English aristocrats with trained professionals. *Thomas Howard, Earl of Arundel* and *The Doctor of Law* share the longest wall in this room. Each man appears in his attire of office. Rubens cast Arundel as a triumphant warrior with a baton in one hand, referring to his position as earl marshal and lord general of the English army. Despite the dazzling suit of armor and commanding posture, Arundel had little military experience and later proved to be a terrible warrior, leading the king's forces into an embarrassing defeat by the Scots in 1639. By contrast, the individual portrayed by Francisco de Zurbarán wears the ceremonial robes of an academic. The full-length format of the portrait also conveys the prestige associated with his office of chair of the law faculty, perhaps at the University of Siguenza. Beyond the respective professions of the men depicted, both pictures attest to the exceptional quality of portraiture that Gardner sought to acquire. *Arundel* was the first major painting by Rubens to enter an American collection.

Despite the high formality of these portraits, Gardner tempered the gravity of the room with lighthearted objects and surprising juxtapositions. Beside the imposing portrait of Alfonso IV d'Este, duke of Modena (by Suttermans), a richly carved cabinet (made in Liguria, Italy) supports a bulbous clay bottle. On its neck, a wide-eyed, bearded man flares his nostrils. Nicknamed "Greybeard Jugs" for their caricaturelike masks, these seventeenth-century stoneware bottles produced in northern Europe were popular containers for liquids thanks to their impervious salt glaze. This example hails from Amsterdam and bears the city's shield on its belly. Brought across the Atlantic during the Revolutionary War, this pot was discovered by a Boston construction firm in the 1870s while digging foundations on the former site of the Brattle Square Church (today City Hall), a building occupied by British troops in 1775. Here in the Dutch Room, elevated on a cabinet into the array of distinguished portraits, the hairy, wild man pokes fun at the serious aristocrats he

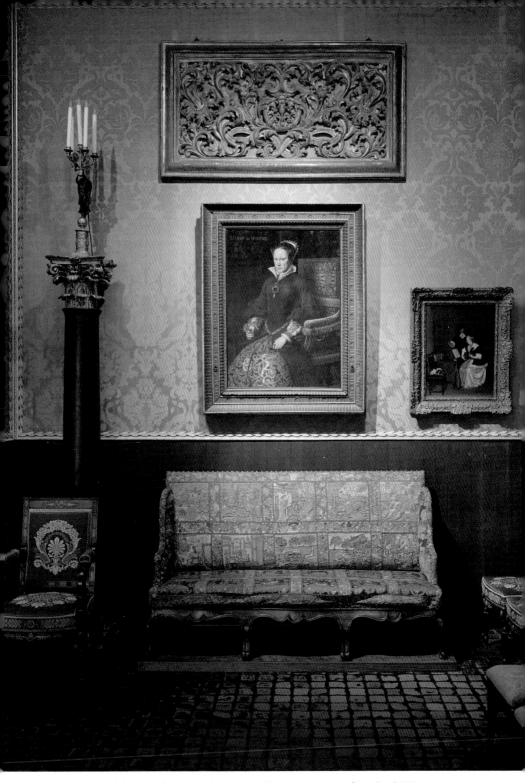

Dutch Room with Antonis Mor and Workshop's *Mary I, Queen of England,* 1554

Peter Paul Rubens, *Thomas Howard, Earl of Arundel,* about 1629–30

German, Frechen, *Greybeard Jug,* early 17th century

accompanies, including the duke of Modena, Anna van Bergen (Marquise de Veere), and the Earl of Arundel.

Another example of Gardner's subversive humor emerges in the far corner. High above a cabinet filled to the brim with silver sits a life-size terracotta bust of a young man. The shaggy fur beneath his red cloak identifies him as John the Baptist (from the workshop of Benedetto da Maiano, Italy). According to the Gospels, King Herod granted Salome one wish, and she asked him for the head of John the Baptist on a plate. In this room the Baptist's bust crowns Gardner's cabinet of silver vessels, perhaps alluding to the biblical story of the beheaded saint.

Gardner freely mixed objects from different cultures and parts of the world, above all in the extraordinary assemblage found within this credenza. Front and center a preening ostrich from seventeenth-century Germany—

German, *Ostrich,* 17th century

made by fashioning silver sheets around the shell of an actual bird's egg—rubs shoulders with a matchbox featuring a menacing figure of the Cambodian god Matchanu. Both objects are placed very close to a Genoese candlestick and a Chinese bat. The latter glides across the surface of a tiny box acquired by Gardner on her 1883–84 trip to China. Nearby, a sprite or nymph emerges from the waves breaking across the surface of a soap box. Designed in the Parisian Art Nouveau style, it was created by the Swedish sculptor Christian Eriksson, who also executed part of the façade of the opera house in Stockholm. Gardner commissioned this bathing scene in 1894 from the artist, through the portraitist Anders Zorn.

Gardner's installations also allude to her social circle by showcasing tokens of friendship: to the right of the silver cabinet a charming pink jade pig shares the table with a green glazed dog. These two Han dynasty tomb figurines attest to Gardner's close relationship with Denman Waldo Ross, the Cincinnati-born art critic and design theorist. He taught art history at Harvard University, served as a trustee at the Museum of Fine Arts, Boston, and collected Asian art. While the former was a gift from Ross, she purchased its

Dutch Room silver cabinet with Workshop of Benedetto da Maiano's bust of
Saint John the Baptist, about 1480

companion on his advice in 1922 for $500. Today they distract attention from the empty frame of Govaert Flinck's *Landscape,* stolen in 1990.

The ceiling is as richly impressive as the canvases and sculptures. Small-scale narrative scenes of mythological subjects, including Leda and the swan, compete for attention with elaborate floral motifs and several coats of arms. With the construction of her museum already under way, Gardner acquired this early sixteenth-century Orvieto ceiling through Richard Norton in Rome. Like the lion stylobates supporting columns over the courtyard, it was one of many pieces of architectural salvage that Gardner directed the architect Willard Sears to incorporate into the building's fabric; the ceiling attests to her meticulous oversight and direction of the construction process.

As in the Raphael Room, light floods in from large windows overlooking the Courtyard, and a double staircase leads into the garden. The Dutch Room played a key role in Gardner's entertaining; she occasionally hosted dinners

Chinese tomb figurines, *Dog,* Han dynasty, 206 BC–AD 220, and *Pig,* about 3rd century BC

Italian, Orvieto, *Ceiling,* about 1500

there, including one for the Harvard football team following their victory over
Yale in 1909. Giants of the art world towered over her guests and sparkled in
the candlelight. They originally included Rembrandt's double portrait, *A Lady
and Gentleman in Black,* and his only seascape, *Christ in the Storm on the Sea of
Galilee,* and Johannes Vermeer's *The Concert.*

THEFT

In the early morning hours of March 18, 1990, a pair of thieves disguised as
police officers entered the Isabella Stewart Gardner Museum, tied up the two
guards on duty that night, and roamed the museum's galleries—eventually
walking out with thirteen irreplaceable works of art. The investigation is still
open and active, and the museum stands ready to receive the works and share
them with the public once they have been recovered. Until that time, the
theft remains an egregious act that deprives visitors to the museum, the city
of Boston, and indeed the world at large access to a number of unique and

extraordinary works, including an ancient Chinese vase, a Napoleonic flag finial, and works by Degas, Manet, Rembrandt, and Vermeer.

Several large, empty frames greet visitors to the Dutch Room, and it is here that the absence of the Gardner's works can be most keenly felt, for two of the museum's most invaluable masterpieces are missing from this space. One, *The Concert* by Johannes Vermeer, is one of only thirty-four works believed to be from his hand. It was, in fact, the first important acquisition that Isabella made, soon after she came into her inheritance in 1891 and embarked in earnest on the formation of a world-class collection. At an auction in Paris,

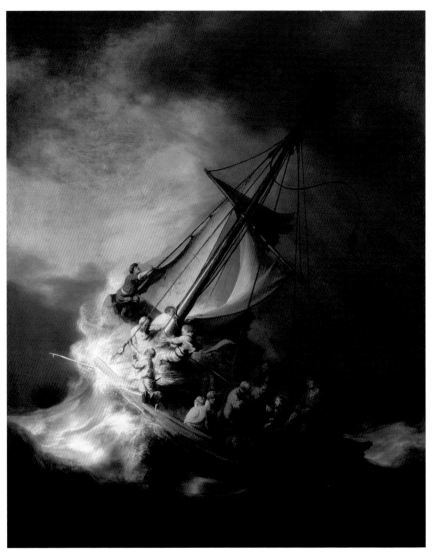

Rembrandt van Rijn, *Christ in the Storm on the Sea of Galilee,* 1633

Sophie Calle, *What Do You See? (Vermeer, The Concert)*, 2013

her agent outbid the Musée du Louvre in Paris and the National Gallery in London for this work, and she became, overnight, a collector with whom to be reckoned. Similarly, Rembrandt's *Christ in the Storm on the Sea of Galilee* is a work of singular importance, as it is the only known seascape by this Dutch master. The small features of Rembrandt himself can be recognized in the face of one of Christ's terrified followers at the center of this composition. Isabella, no doubt intentionally, placed this grand canvas, with its diminutive image of the painter, directly across the gallery from his earlier tour de force, the *Self-Portrait, Age 23*. Today, the young, precocious master looks out from the painting on the north wall of the room and across to the south wall and sees only a void in an empty frame, as do all other visitors to the Dutch Room, for the time being at least. While the theft continues to pique the public's curiosity—and has provided poignant inspiration for new works of art like Sophie Calle's 2013 *What Do You See? (Vermeer, The Concert)*—the museum, and the world, remains hopeful they will one day be returned to their proper places in the museum's galleries.

THIRD FLOOR

STAIRHALLS

As in the Long Gallery, Gardner had the main stairwell from the Courtyard to the second and third floors painted Bardini Blue, the iconic color favored by the Florentine gallerist Stefano Bardini. Against this vivid backdrop she positioned a number of architectural fragments, sculptures, and other decorative elements made of different materials, including wood, metal, and stone. Noteworthy among those on the stairway leading to the first floor is a Roman marble altar frontal with a cross on one side and geometric and flower patterns on the other. Furniture, tapestries, and a door from a Florentine palace greet visitors on the second-floor landing, while a battle scene unfolds across a golden Edo-period (seventeenth century) Japanese screen close to the bottom of the stairs leading to the third floor. Tucked high against the ceiling, and visible from the middle of the stairs to the third floor, is a fresco of serenading musicians by Giorgio Vasari, painted in about 1545.

More wooden Italian furniture and *The Portrait of a Lady in Black*, painted just before 1600 by Tintoretto, appear at the top of the stairs. A number of important tapestries also hang nearby, including the earliest tapestry in the museum's collection, *Amazons Preparing for a Joust*, produced in the southern Netherlands in about 1450. Another Netherlandish tapestry, *The Fulfillment of the Curse on Ahab*, designed by Rogier van der Weyden and made about 1460,

Second Floor Stairhall looking south

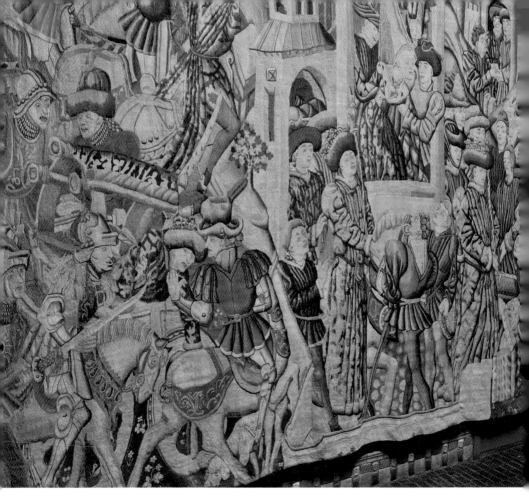

Third Floor Stairhall with the tapestry designed by Rogier van der Weyden, *The Fulfillment of the Curse on Ahab,* about 1460–70; and tiles by the Moravian Potter and Tile Works, about 1901

is displayed on the opposite wall. Jezebel and Ahab figure prominently in the center of an otherwise crowded composition of courtly figures displaying the height of chivalric fashion from the later Middle Ages; the gruesome detail of severed heads in a coffer can be seen in the lower right corner. Ever attentive to even the smallest detail, Gardner positioned a series of small but brilliantly colored tiles from the Moravian Potter and Tile Works, decorated with a design from the Norman Castle Acre (Norfolk, England), below this tapestry.

Heading toward the Gothic Room and just beyond the now-open gate that was kept closed during Gardner's lifetime, an early twelfth-century *Crucified Christ,* carved and painted for a church in Catalonia, Spain, comes into view. This sculpture, along with other devotional works, including a Spanish *Retable with Scenes from the Life of the Virgin* and the Italian painted and gilded terracotta *Deposition of Christ with the Donor Carlotta of Lusignano,* set the stage for the Gothic Room, which features an array of religious items.

VERONESE ROOM

Of all the Renaissance painters adored by Gilded Age collectors and amateurs, Paolo Veronese ranks among the top. His lush visions of heaven, vast biblical banquets, and sumptuous mythological scenes evoke a richly operatic fantasy of Renaissance Venice that fueled the imagination of Gardner and her friends. Successful merchants ruled the lagoon city during its Renaissance-era golden age, their families having achieved social status and political power through accumulated wealth (via trade) and longevity. Such circumstances probably resonated with Boston's oldest families. The patina of age was a prerequisite of this city's ruling class, investing scions of mercantile fortunes with respect and authority. Boston's many Venetian-inspired buildings, including this one, embody its citizens' desire to seek links with the lagoon city's past.

Many of Gardner's friends and acquaintances shared her obsession with Venice. Henry James described his "inevitable Venice-hunger," relieved only by annual visits. Like the characters in his novels, they stayed with American friends in the once-lavish residences of the Venetian ruling elite, often renting palaces along the Grand Canal. If the palaces were not already furnished with art accumulated over several centuries, then the new American tenants' acquisitions transformed them according to how these New World natives imagined that the palazzi of venerable Venetian patricians should look. The Curtis family—whom James addressed as "you, children of Veronese"—even rebuilt the façade of Palazzo Barbaro to make it appear more to their tastes, just as Gardner created her own fantasy of a "Venetian" palace on Boston's Fenway.

This room, which invites you to share Gardner's Gilded Age dream of Venice, takes its name from the painting on the ceiling. While American collectors like John G. Johnson of Philadelphia idolized Veronese's most famous works, his vast mythological scenes and towering altarpieces were both hard to come by and impractically large for most houses. Yet, in 1899, while construction of the museum was well under way, Gardner acquired the canvas attributed to Veronese (now thought to be by the studio of Veronese) and painted for the Dalla Torre family's mainland palace at Udine in the 1580s. Crowned with the flowers of Cupid in a court of gods and goddesses, *The Coronation of Hebe* was a subject fit for the queen of Fenway Court by a painter whom she and contemporaries held in high esteem. Gardner commissioned gilded paneling in Milan to frame it in appropriate splendor. Not content with a single Veronese, she later acquired a drawing for his most famous altarpiece—the *Mystic Marriage of Saint Catherine*—which stands on the easel to the left of the fireplace.

Rather than privileging any one style or period, Gardner carefully constructed a splendid assemblage. Like a salon on the Grand Canal, this room

Veronese Room looking north

overlooks Boston's Muddy River, transforming Fenway Court into a palace of dreams. She filled the Veronese Room with the kind of possessions that might have piled up in a Venetian palazzo over countless generations of patrician ownership. The gray-wigged grandee between the windows presides over it all like a celebrated ancestor. The portrait commemorates Pietro Pisani's 1701 appointment as one of the procurators of Saint Mark's, a government office in Venice second only to the doge—the elected ruler of Venice—and, like that position, held for life. He gazes down and toward two paintings by Francesco Guardi and a follower that unite symbols of the city's political and religious authority. Above, offering a view into Saint Mark's Square, Guardi depicts the procurators' office building on the left and the basilica of Saint Mark on the right. Church and state alike set their schedules by the spectacular clock in between. In the painting below, the Doge's Palace rises from the lagoon like a

Venetian, *Mirror*, last quarter of the 18th century

pink marble mist. Nearby ships unload their cargoes along the port's principal embarkation area, the Riva degli Schiavoni.

Venetian identity was defined in part by the city's ability to obtain luxury goods from abroad and to produce them for export. From leather to lace, Gardner gathered a constellation of imported objects of diverse provenance. Stamped and painted leather panels from Spain, Italy, and the Netherlands line the walls and absorb the light, setting a tone of aged and faded grandeur. Gardner had the floorboards of this room stained with a translucent paint containing bronze to match the walls. Many other works in the room speak of the taste for the luxury trade. Gardner collected antique lace with the same acquisitive fervor with which she bought pictures. The corner cases display remarkable Flemish, Italian, and French examples, including one seventeenth-century panel depicting an allegory of King Louis XIV. Collections of fine

Paolo Veronese, *Mystic Marriage of Saint Catherine,* about 1575

Studio of Paolo Veronese, *The Coronation of Hebe,* about 1580–89

lacework in America were believed to be pertinent to the textile industry, but they also spoke of aristocratic tastes. Upper-class women gave one another gifts of lace, as well as bought and sold it. Gardner purchased the French allegory from Lady Kenmare in 1897.

The theme of travel also plays an important role in this room. Although Gardner's installation creates a metaphoric journey through time and space without ever leaving Boston, she also introduced the actual modes of transit for more literal expeditions. A deluxe sedan chair with an upholstered wooden compartment sits on the floor near the entrance and evokes the height of pre-automobile luxury transport. At the desk opposite, an eighteenth-century gig chair recalls another means of travel. Gardner called the little seat her "gondola chair" and was carried in it through the museum after 1919, when a stroke rendered walking difficult. Probably made in Venice, the gig chair was

Follower of Francesco Guardi, *The Torre dell' Orologio, Venice,* late 18th–early 19th centuries; and Francesco Guardi, *View of the Riva degli Schiavoni and the Piazzetta from the Bacino di San Marco,* 1760s

intended for a two-wheeled horse carriage. The Chinese figures that decorate its sides suggest the lagoon city's far-reaching trade networks and the impact of imports on local designs. These two objects are the ultimate in armchair travel. Each conjures a distant, foreign past and yet both stand plunk on the floor in front of you.

Gardner's installation draws together all the elements of a domestic environment and yet was never intended to be used as one. Gilded china saucers and cups, along with a pitcher, glisten on a small table at the room's center. Gardner laid the table with this early nineteenth-century French tea service, and it waits in perpetual readiness for a queen who never seems to arrive. Nearby, between the windows, an eighteenth-century marble-topped console table, carved with a caricature and thick festoons, serves as the altar to a little shrine. Green glass candlesticks, majolica apothecary jars (1701), and French gilded-bronze candelabra flank a black Virgin Mary constructed from fragments of Murano glass. Like the table and desk, this elaborate shrine does not so much await a person to use it—a worshipper—as create an impression, in this case of a lavish domestic chapel. In the corner, Gardner laid the finely carved wooden writing desk with a set of ink pots, a Japanese lacquer ink-stone box, and a Venetian glass candlestick in the shape of a dolphin. Of course, she never intended for anyone to sit in the gig chair or put the objects to use. Instead, her carefully crafted office space stands at attention for a traveler or correspondent who exists only in the imagination.

Nearby, she hung a series of small pictures. Painted in about 1752, *The Wedding of Frederick Barbarossa to Beatrice of Burgundy* is an oil sketch for one episode in a monumental cycle of frescoes in the Archbishop's Palace in Würzburg, Germany, created by Giovanni Domenico Tiepolo. Both he and his father, Giovanni Battista, hailed from Venice. Like eighteenth-century Veroneses, they filled the palaces of the city's upper classes with dramatic narratives in fresco. Four small pastels by James McNeill Whistler form a group below. They include *The Little Note in Yellow and Gold,* acquired by Gardner in October 1886 (and the earliest nonphotographic portrait of Isabella to enter the collection); *The Sweet Shop, Chelsea; The Violet Note;* and *Lapis Lazuli.* This last work is one of the few nudes in the collection, a popular genre of painting in Renaissance Venice. Here it offers a modern complement to Veronese's voluptuous women who inhabit the celestial sphere above our heads.

Gardner's museum and its Veronese Room left a powerful impression on her contemporaries. Edith Wharton seems to have had both in mind when writing *The House of Mirth* in 1905. She described a mansion in Gilded Age New York that shares the museum's theatrical qualities and ephemeral impression—"one had to touch the marble columns to learn they were not of

Lace cabinet, Veronese Room

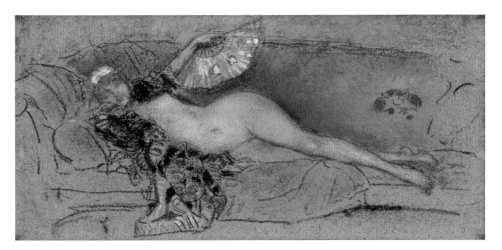

James McNeill Whistler, *Lapis Lazuli*, 1885–86

cardboard." In fact, the courtyard of Gardner's museum features Venetian-style crenellations, which are made of papier-mâché and chicken wire! In one of the book's rooms, a party unfolds beneath a splendid Venetian ceiling, later identified as the work of Paolo Veronese, and it is tempting to see a parallel between the room in Wharton's novel and this one, which the author would have visited at the opening of the museum in 1903. Veronese's painted world of myth and fantasy remained a touchstone for the American fascination with Venice. In James's *Wings of a Dove*, the protagonist, Milly Theale, reigns over the richly decorated Palazzo Leporelli, loosely based on the actual Palazzo Barbaro. Although Theale did not possess a Veronese, James compares her life in the palace to one of the painter's spectacular feasts. He brings Veronese's world vividly to life in the novel, just as Gardner animated this corner of her museum around the painter's ceiling, evoking impressions of Venice and making the Venetian artist more relevant than ever to herself, family, friends, and visitors.

TITIAN ROOM

The Titian Room, an opulent spectacle of Renaissance painting, Baroque textiles, and Rococo furniture, sets the stage for some of the museum's finest masterpieces. Titian's *Rape of Europa*, painted in Venice in the 1560s, dominates the space. The painting, inspired by a story from Ovid's *Metamorphoses*, unfolds across the canvas. Infatuated with Europa, Jupiter—king of the gods—transforms himself into a beautiful white bull and joins a herd grazing near the seashore. Europa, close by with her companions, approaches the beautiful creature with hand outstretched. Finding him tame, she plays with the bull in a meadow and entwines flowers around his horns. When she climbs playfully on

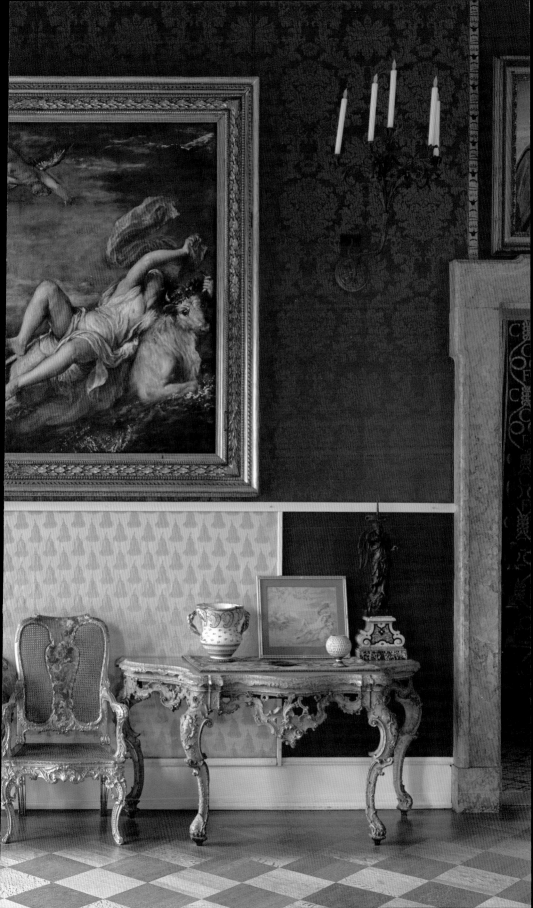

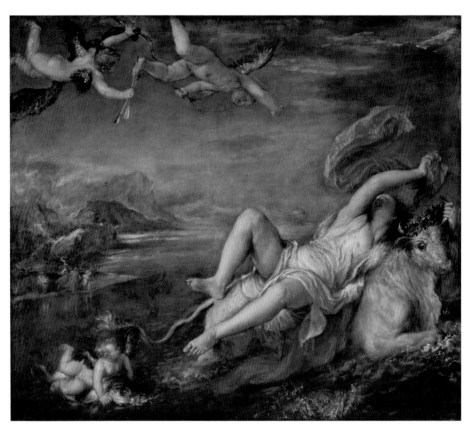

Titian, *Rape of Europa,* 1562

his back, the mischievous god seizes the opportunity and springs into the sea, spiriting away the target of his affections while she clings to him in terror.

Jupiter races across the ocean and Europa holds on by one horn. Gazing back over her shoulder toward the shoreline, she waves a red silk veil to attract attention. Europa's companions respond with their own frantic signals (note the herd of cows still grazing to their left). Titian dramatizes her immediate danger of drowning by positioning in the foreground a menacing, scaly sea monster bristling with spines. Nearby a cupid chases after Europa on a dolphin. His pose mimics hers, perhaps poking fun at her plight. The forced union of Europa and Jupiter eventually led to a historic event: the birth of Minos, king of Crete and the Minoans, the first European civilization.

With the help of Berenson, Gardner bought Titian's *Rape of Europa* from the Earl of Darnley in 1896, and it became the crown jewel of her museum's growing collection. When the painting arrived in Boston, she wrote with delight to Berenson, "I am back here tonight ... after a two days' orgy.

Previous pages: Titian Room looking east

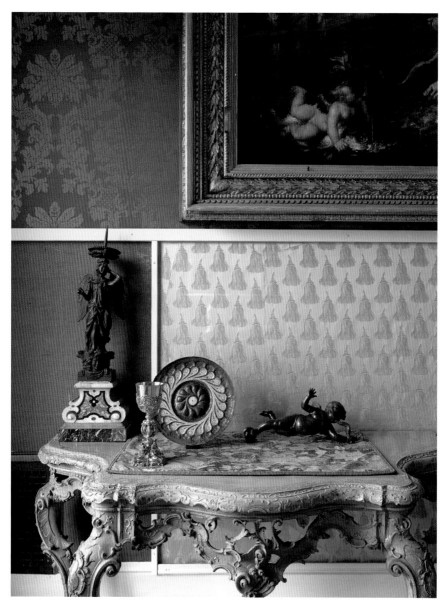

Titian Room with a follower of François Duquesnoy's *Cupid Blowing a Horn,* 17th century; and silk from a gown designed by Charles Frederick Worth, about 1885–91

The orgy was drinking myself drunk with Europa and then sitting for hours in my Italian Garden at Brookline, thinking and dreaming about her." It became a moment to remember. Several years later, Henry James recollected the announcement, rapt with admiration for Gardner and her new painting: "It's difficult to believe how long it is since I sat in your high saloon at the Savoy & hung on your lips while you hung your Europe [*Rape of Europa*] before me. As she hangs before *you* now (incredible woman!—I mean *both* of you)."

Gardner reinforced and elaborated on themes in the painting's composition with her installation. A bronze cupid blowing a horn—attributed to a follower of François Duquesnoy—reclines on the table below, calling attention to Titian's little dolphin rider. A swath of silvery fabric glistens behind two Venetian console tables. This fragment of a Charles Frederick Worth–designed gown—which Gardner wore to the 1891 Myopia Hunt Club Ball in South Hamilton, Massachusetts—extends the impression of a shimmering sea out of the painting and into the room. Each stylized tassel of its woven pattern resembles the bull's bushy tail, which playfully grazes a cupid's head. Two more works of art, both tokens of appreciation, attest to this painting's fame and the story's continuing appeal to artists. Propped against the wall, a seventeenth-century drawing after Rubens's copy of *Europa* acknowledges its enduring popularity long after Titian's death. The American sculptor Paul Manship designed his own version of the mythological abduction. He presented a cast of it to Gardner, and in 1917 she gave it pride of place on the table in front of Titian's *Europa*.

Other deeply personal arrangements form an integral part of this room's ensemble. Just to the left of Titian's masterpiece, one of Gardner's favorite paintings hangs above a small table perpetually set with flowers. *Christ Carrying the Cross* shows the savior in dramatic close-up, crowned by thorns, with translucent tears streaming down his cheek. Gardner acquired this painting as a work of the Venetian Renaissance painter Giorgione, but it is now attributed to Giovanni Bellini or Vicenzo Catena. Competition with the Museum of Fine Arts, Boston, for the weeping savior prolonged the negotiations for almost two years, but she finally concluded the deal in December 1898, shortly after the death of her husband, Jack. As if to transform the painting into a memorial, Isabella placed violets—her favorite flowers—before it in a silver cup that they had purchased on a trip to Norway in 1867. The museum continues her tradition to this day.

Venice plays a starring role in this room in both obvious and unexpected ways. Natural light from the Courtyard skylight floods the Titian Room through Venetian Gothic marble windows. In addition to the celebrated Titian and *Christ Carrying the Cross,* such paintings as *Christ Disputing in the Temple* by Paris Bordone and Bonifazio Pitati's *The Story of Antiochus and Stratonica* compete for attention with an array of objects that includes a marble portrait bust of a procurator of Saint Mark's. Glass vases and gilded furnishings reinforce the impression of this city. Notable among them is a brilliant blue glass pitcher speckled with white, one of a pair purchased in Venice by Jack in 1897. Their installation on creamy white chests elevates the status of the seemingly simple jugs by recalling grander displays of fine porcelain. Always one for subterfuge, Gardner undermined the formality of this arrangement with a joke. One of the

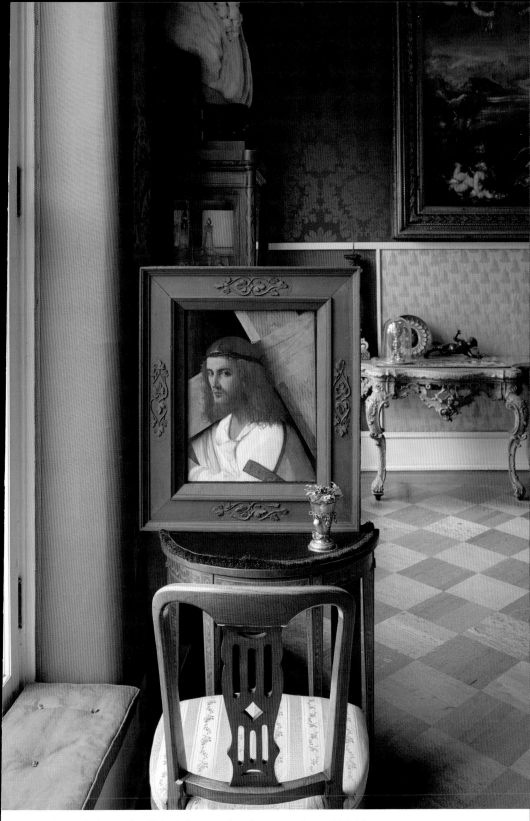

Circle of Giovanni Bellini, *Christ Carrying the Cross,* about 1505–10

eighteenth-century Venetian nightstands conceals a false front that pops open to reveal a politely hidden compartment for the chamber pot.

A lavish seating arrangement of eighteenth-century chairs fills the middle of the room. Six Roman Rococo chairs and two Neapolitan marble tables appear to await notable visitors. Each features an elaborate confection of visual effects. Carved for the Borghese Palace in the late eighteenth century, the chairs' intricate wooden frames simulate the appearance of gilded bronze (*ormolu*)— a far more expensive material. The shapely splats or backs pucker at the edges, suggesting the texture of an animal pelt, and are carefully painted with tiny flowers. Gardner was immensely proud of these rare examples of fine Rococo furniture, and she placed another chair from the set directly beneath her prized Titian, where its bouquet of delicate blossoms calls attention to the bull's crown of wildflowers woven by Europa herself. Gardner arranged all seven of the spectacular seats, conveying the effect of a stage perpetually set for distinguished guests. The carpet beneath their feet also delivers a theatrical impression. John Singer Sargent originally intended it as the backdrop for a society portrait, but the vibrant pattern so overwhelmed the sitter's delicate likeness that he painted it out. Instead, Gardner acquired the prop for her Titian Room on Sargent's recommendation in 1894.

More than mere decoration, the sumptuous trappings of this room make visible the power held by the aristocrats depicted in the room's paintings through their noble provenance. King Philip II of Spain, for example, commissioned the *Rape of Europa*. This mythological painting faces a formal, full-length depiction of Philip's sister Juana of Austria by the female portraitist Sofonisba Anguisola. To the right of *Europa*, Philip II's grandson surveys the scene. The Spanish court painter Diego Velázquez depicted King Philip IV with his hat off and standing near a table, as if prepared to receive a diplomat or petitioner. Together, these three paintings attest to the pan-European rule of the Hapsburg dynasty, recalling moments in history when aristocrats wielded political power and relied on elaborate ceremony to project regal authority.

The political might of hard and soft power—whether bestowed by dynastic lineage or appointment—fascinated Gardner, and she filled this room with the trappings of high office. An imposing weapon hanging horizontally above the two Venetian jugs must be understood in this light, for it is no common spear. The blade boasts a coat of arms of a noble family. Probably made in about 1605 for Cardinal Scipione Borghese-Caffarelli, it was wielded by a member of his bodyguard. Its velvet-wrapped handle complements a red ceremonial textile woven with metal threads. The crown above frames military trophies, suggesting success on the battlefield for the Italian aristocrat who commissioned it. The juxtaposition offers a literal reminder of the powerful alliance between church and state.

Titian Room looking north

Following pages: Titian Room looking southwest

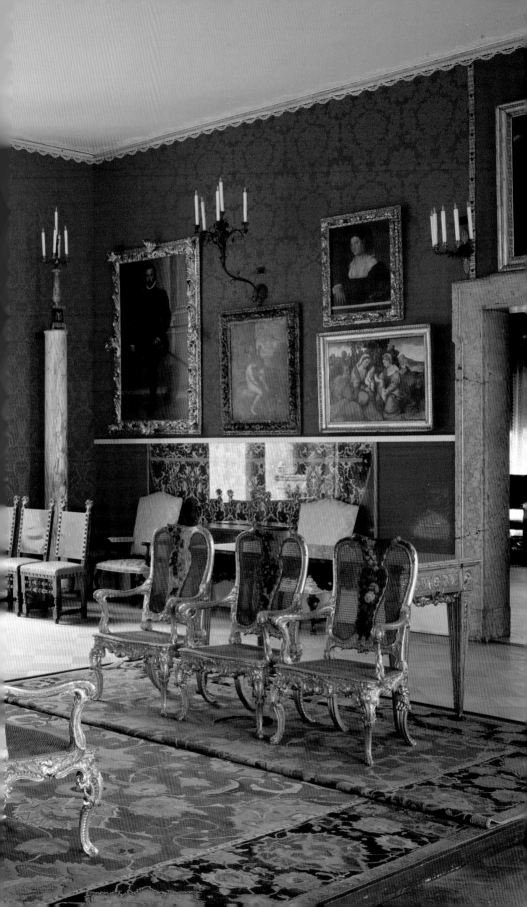

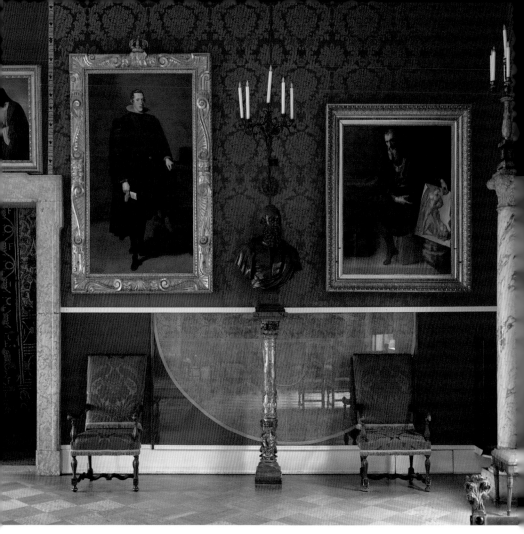

Titian Room looking east

Three of the other four walls underscore this relationship with sumptuous ecclesiastical vestments. Beneath the paintings Gardner unfolded three large copes, the ceremonial cloaks worn by bishops. Each great swath of silk calls attention to the paintings and sculpture above it. Together they symbolize the means by which earthly sovereigns claimed their divine right to rule and layer yet another meaningful stratum of luxury on an already extravagant ensemble.

Both real and imaginary personalities on the south wall add to the impression of splendor. If *Woman with a Turban* by Francesco Torbido was acquired by Gardner as a portrait of her Renaissance idol, Isabella d'Este, the identity of the sword-bearing young man painted by Giovanni Battista Moroni remains a mystery. He cuts a dashing figure in his black silk tunic and hose, conjuring the image of a well-heeled courtier at ease in such a splendid environment. Together they address an august company on the opposite wall. A stupendous bust by

Sofonisba Anguissola, *Juana of Austria and a Young Girl*, 1561–62

the sculptor Benvenuto Cellini of the Florentine aristocrat and papal banker Bindo Altoviti joins a self-portrait of the artist Baccio Bandinelli and Velázquez's King Philip IV in an impressive lineup of personalities, bringing history to life.

LONG GALLERY AND CHAPEL

One continuous gallery running along the south side of the building, the Long Gallery is an art gallery, an archive, a library, and a chapel all at once. To walk along this corridor is to stroll through time, from antiquity to the turn of the twentieth century, and past a vast array of objects—ancient sculpture, church furniture, modern letters, photographs, rare books, Renaissance paintings—all set against a palette of brilliant blues and glimmering golds. Several architectural guideposts mark designated zones. One of these zones, the Chapel at the

Long Gallery looking north

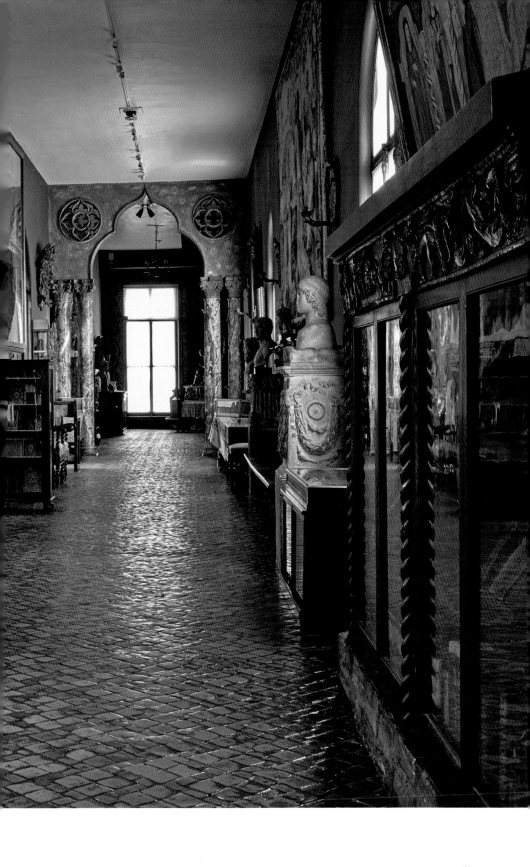

Long Gallery with Sandro Botticelli's *Virgin and Child with an Angel*, 1470–74; Northern Indian, *Helmet,* 17th century–18th century; Syrian or Egyptian, *Fragment of a Mosque Lamp* and *Mamluk Bowl,* both mid-14th century

south end, was off limits to visitors during Gardner's lifetime, blocked by a screen. At the other end of the Long Gallery, an elaborate portal, complete with rose-colored marble columns, ogival arches, and openwork trefoil roundels, quietly separates an intimate alcove of paintings and sculpture from the long central section of the corridor and encourages one to pause.

At this northern end, a serene and contemplative corner, two paintings by Sandro Botticelli face one another. On one side is a tondo, or circular composition, with an image of the Nativity, painted in the early 1480s by the Florentine master. It shows Joseph carefully placing the Christ Child down to rest in the copious folds of his mother's mantle. She gazes down at him lovingly, her hands clasped as if in prayer. Across the room is a *Virgin and Child with an Angel,* completed ten years earlier. One of the undisputed masterpieces of the museum's collection, it bears all the stylistic hallmarks of an early Botticelli: the graceful beauty of the saintly figures is emphasized by soft contours and pastel colors. While the Virgin contemplates a sheaf of wheat, foreshadowing Christ's

Sandro Botticelli, *Virgin and Child with an Angel,* 1470–74

sacrifice and the sacrament of the Eucharist, the chubby baby playfully accepts his eventual fate by raising his right hand. His other hand, however, rests on one of Mary's, a loving moment shared by a child and his mother and a symbol of his vulnerable, human status. The rich blue tones of their garments are offset by the gold of their hair and by the decorative threads that cap the Virgin's sleeve and highlight the stalks of wheat. This play of blue and gold on the panel can also be seen on a fourteenth-century gilded and enameled glass mosque lamp, made in either Egypt or Syria, which sits on a Tuscan credenza below the

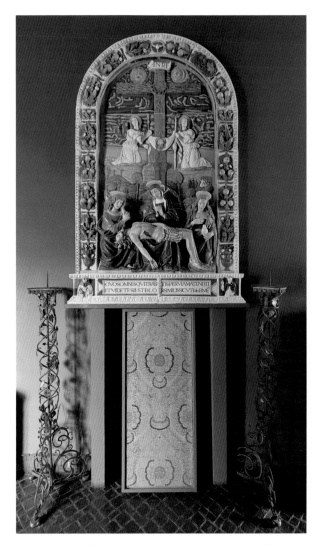

Long Gallery with Giovanni della Robbia's *Lamentation over the Dead Christ,* about 1515; and an Italian furnishing and garment fabric, 1475–1525

painting. Two other objects from Islamic lands stand on either side of the lamp. To the right is a fourteenth-century bowl made of brass, with silver images of confronting horsemen; to the left is a northern Indian metal helmet with an inlaid pattern of golden arabesques, or scrolling foliage pattern.

The Long Gallery is also home to two works from the prolific Renaissance workshops of the Della Robbia family, famed for their colorful, glazed terra-cotta sculpture. A tabernacle by Andrea della Robbia, with two brilliant opaque white angels surrounding a brass door, appears to the left of Botticelli's *Virgin and Child with an Angel;* the cerulean blues in the archway above its doors and its shiny golden frame recall the play of blue and gold so prevalent in the Botticelli

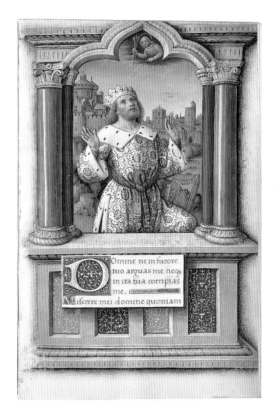

Jean Bourdichon,
*Book of Hours: King
David,* 1490–1515

and the arrangement of objects below it. Completely different in appearance is Giovanni della Robbia's *Lamentation over the Dead Christ,* a whole altarpiece situated a few paces down from the *Tabernacle* produced by his father. Yellow, brown, and a vivid green mix with white and different shades of blue to produce an almost startling effect, a colorful image that demands attention and rewards inspection. Below the *Lamentation,* Gardner installed a framed piece of Italian patterned velvet, equally rich in appearance with gilded threads and red dyes (now faded); Sargent used this fabric as the backdrop for his iconic portrait of her that hangs in the adjacent Gothic Room.

The devotional theme of the *Lamentation* finds an echo in another Renaissance painted and gilded terracotta sculpture group across the way: a roundel showing the Virgin and Child by Benedetto da Maiano, a master who may have trained the young Michelangelo in the art of sculpting marble. Below this sweet image of the Virgin and her playful, squirming son, however, Gardner positioned a bookshelf and a case on top of it, which set a very different tone. In this case, called the Presidents and Statesmen Case, Gardner displayed letters and autographs of thirteen American presidents, including George Washington, John Quincy Adams, and William Howard Taft. A photograph of Theodore Roosevelt, signed and presented to Gardner in 1904, just as she had opened the

museum for the "enjoyment and education of the public forever," reminds us that her collection was intended to serve a civic function and that she had the future in mind as much as the past at the start of a new century.

The twelve cases in the Long Gallery preserve a large portion of Gardner's literary and historical manuscripts, personal correspondence, rare books, fine bindings, collected letters, and other memorabilia. One masterpiece of the more than nine hundred books and manuscripts in this gallery is a handwritten and illuminated Book of Hours by Jean Bourdichon, a French Renaissance artist active at the court of François I.

In addition to the collection of presidential material, Gardner showcased her admiration for authors, displaying ephemera related to Charles Dickens, John Keats, Percy Bysshe Shelley, Oscar Wilde, Jean-Jacques Rousseau, Voltaire, Victor Hugo, and George Sand, among others; for actors, including Ellen Terry and Sarah Bernhardt; and for artists, including Manship, John La Farge, and Anders Zorn. One case holds tokens of her close friendships with the painters Sargent and Whistler, such as drawings Whistler made of the Peacock Room (Freer Gallery of Art, Washington, DC), which Gardner tried to secure for the Boston Public Library, and a bronze medal of Sargent by their friend Augustus Saint-Gaudens. Paintings, ancient sculpture, medieval ivory carvings and metalwork objects, tapestries, and priestly vestments round out the panoply of objects that adorn the middle section of the gallery.

J. B. Pratt, Sargent-Whistler Case

Opposite: Long Gallery with the Dante Case and Giuliano da Rimini's *Virgin and Child Enthroned with Saints,* 1307

Paul César Helleu, *The Interior of the Abbey Church of Saint Denis,* about 1891

The largest and most prominent of all the cases in the gallery stands at the west end, near the Chapel. One of the last cases that visitors to the museum would have seen during Gardner's lifetime, it attests to her lifelong admiration for and study of the writings of Dante Alighieri, the great medieval Italian poet. Beginning in the 1880s, Gardner began her study of Dante's texts in courses at Harvard with Charles Eliot Norton. Though she had no formal advanced education, she had been an avid student of literature, and of the Italian language, for most of her adult life. With advice from Norton and other experts, Gardner eventually collected a number of rare print editions of the *Divine Comedy* by Dante, which she displayed in this case. The only female member of the Dante Society, which was founded by Henry Wadsworth Longfellow, James Russell Lowell, and Norton, she supported its scholarly pursuits, including the first published *Concordance of the Divine Comedy.* She stored these volumes in this case, as well as a death mask of Dante that she received as a gift from the society. Her love of Italian literature, and her collecting of it, preceded her collecting of fine art by nearly a decade and may have acted as a foundation for it—a theory suggested by the fact that she positioned an important early Italian painting by Giuliano da Rimini, *The Virgin and Child Enthroned with Saints,* on top of this case devoted to Dante's writings. Painted in 1307, as the inscription notes, it dates to the same decade as Dante's legendary exile from his beloved Florence.

The Chapel, at the far south end of the gallery, houses a consecrated altar and was used by Gardner, a devout Anglo-Catholic, for the celebration of Mass in her lifetime, including the first Mass held here, on Christmas Eve of 1902, six days before the museum opened. Its function as an active sacred space is still upheld every April when, as specified in Gardner's will, a memorial service honors the memory of the museum's founder. Liturgical items, including an early seventeenth-century Italian carved ivory crucifix and a cloth that Gardner crocheted herself, adorn the altar table.

A magnificent Gothic stained-glass panel, from the cathedral of Soissons in France, stands as the centerpiece of the Chapel. The historian, novelist, and critic Henry Adams encouraged Gardner to buy it, and she did, believing that it was from the basilica of Saint-Denis outside Paris. At the right time of day, when the sun shines through the glass, the tile floor before it is bathed in a kaleidoscopic wash of colors. This atmospheric play of shifting light and flecks of color can be seen on the slabs of stone speckled with color by medieval stained glass in the nearby painting by Paul César Helleu, his 1891 *Interior of the Abbey Church of Saint Denis.* The incomparable blues of French Gothic stained glass transform virtually any architectural space, as they do the museum's Chapel. The blues in the background of scenes from the life of Saint Nicasius, the first

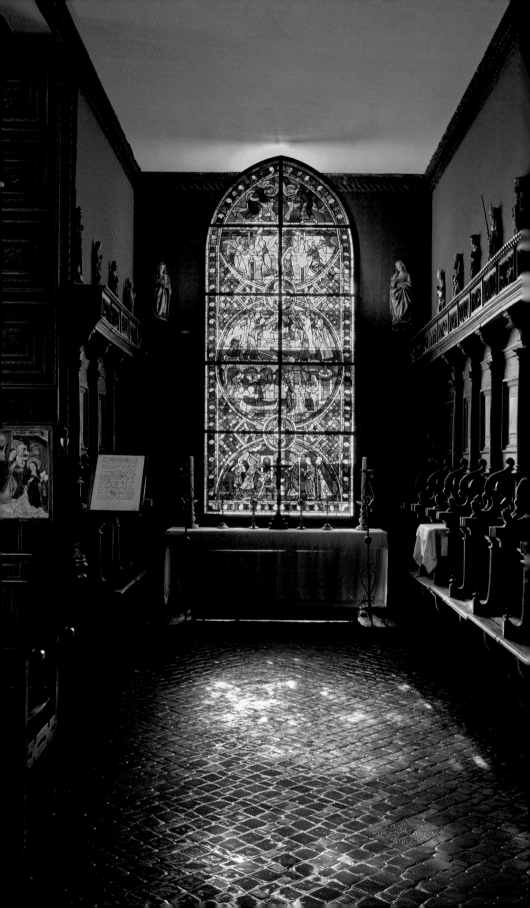

bishop of Rheims, command attention and yet work in harmony with the blues visible throughout the Long Gallery, particularly the saturated blue surfaces of the surrounding walls, known now as Bardini Blue.

Gardner had seen a particular shade of blue on the walls of the palazzo in Florence of the antiquarian dealer Stefano Bardini and wished to replicate it at Fenway Court. In 1910 she wrote to Berenson, "Will you please someday get a piece of paper with the blue colour that Bardini has on his walls? I want the exact tint." Berenson sent her a sample, but she ripped it in half and sent it back to him, insisting that it was not a true match. Always exacting, she instead decided on a mixture of water-soluble paint composed of ultramarine green, ultramarine blue, whitening agents, and glue that achieves a vivid twilight blue that has a matte surface very different from that of modern oils or latex finishes. The rich surface absorbs light rather than reflects it and imparts a feeling of spaciousness. The lush color complements the works set against it in an extraordinary way, emphasizing the variegated texture and warm tones of the northern Italian walnut and chestnut choir stalls in the Chapel, and it heightens the glittering effects of the gilded and painted early sixteenth-century German lindenwood saints above them. Perhaps most extraordinary, it does not detract from but, rather, complements perfectly the jewel tones of the Soissons window and, like the colors of the Gothic glass, bathes the gallery in a celestial blue.

GOTHIC ROOM

The Gothic Room was closed to the public during Gardner's lifetime. With its mixture of devotional and domestic objects, it served as a private refuge for her and a few very close friends. A far cry from the Italian palazzo–like aesthetic she employed in the grand galleries of the museum, such as the Raphael Room or Titian Room, here she called on another style near to her heart: the Gothic. Inspiration for this space came from her earlier sojourns to England, where she saw that country's many Gothic cathedrals, painstakingly recorded in her travel albums. With Gardner's life-size portrait practically holding court in the southwest corner of the room, this gallery is the one in which the lingering spirit of the museum's founder can be most keenly felt. As the installation of objects here suggests, it was a spirit that was intensely devout, often witty or irreverent, and, above all, fiercely passionate about creative pursuits.

On a sunny morning, light permeates this room through the impressive medieval windows inserted into the fabric of the south wall. A Gothic limestone

Chapel with the Soissons window: *Scenes from the Lives of Saint Nicasius and Saint Eutropia,* about 1205

Following pages: Gothic Room looking southwest

Gothic Room
looking south

wheel window, originally from a church in southern Italy, forms the centerpiece
of the composition. To its sides are several Italian stained-glass windows that
come from Milan Cathedral, made about 1480, with ceremonial and biblical
imagery, including *Christ Washing the Feet of the Disciples* and *A Baptism*. Above
them are two German windows from a parish church in Austria, also dated to
the 1480s, with images of the donor, Lienhard Jöchl, and his wife, Dorothea,
along with their sons and daughter; Saints Peter and Andrew appear alongside
the Jöchls in the panels. When the sun penetrates these windows, it bathes the

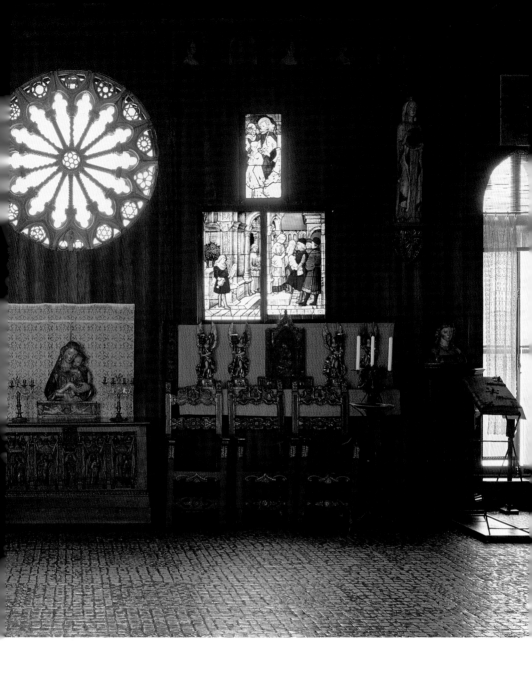

ocher-colored Mercer tiles on the floor in a warm glow. This radiant light, contrasting with the dark wood-paneled walls, further accentuates the many golden surfaces of the room's paintings, frames, and other objects. The effect, overall, is a space imbued with an almost otherworldly luminescence.

Sargent's iconic portrait of Gardner, painted in 1888 when she was in her late forties, glitters along with the best of them, holding its own and commanding attention. The large golden frame around the work shimmers, and Isabella's pale skin glows against the black velvet of her dress. Barely contained within the

Simone Martini, *Virgin and Child,* about 1325

shallow space of the painted surface, she looks straight out, with lips parted as though in speech. Her form-fitting Parisian gown, accentuated by the rubies and pearls at her neck, waist, and feet, stands in stark contrast to her radiant flesh. In this way, it imitates Sargent's scandalous portrait *Madame X* that was displayed at the Paris Salon four years earlier (The Metropolitan Museum of Art, New York). Clearly intrigued by the boldness and the beauty of *Madame X,* Gardner encouraged Sargent to flout convention with her own portrait. She even placed another image of the earlier sitter, Virginie Gautreau, several floors down; Sargent's *Madame Gautreau Drinking a Toast* hangs in the Blue Room. Gardner's unorthodox portrait caught the eye of polite Boston society and sent tongues wagging when it was displayed at an exhibition at the St. Botolph Club soon after Sargent finished painting it. Dismayed by the scandal, Gardner's husband asked her to refrain from displaying it publicly during their lifetimes.

John Singer Sargent, *Isabella Stewart Gardner,* 1888

Giotto, *The Presentation of the Christ Child in the Temple,* about 1320

Ironically, or perhaps purposefully, in contrast to the scandalous pose and dress, the patterned cloth behind Gardner—an Italian voided velvet in her collection, on view in the Long Gallery beneath Giovanni della Robbia's *Lamentation*—places her in an otherworldly realm and imparts a halo-like effect that prompted Henry James to proclaim her "a Byzantine Madonna for our time." Gardner furthered this comparison by installing the painting in an arrangement that suggests her portrait might function like an altarpiece: it is positioned over a large wooden chest, and on top of the chest is a large choir book from a church in Naples.

Two of the museum's most important early Italian panel paintings stand in close proximity to her portrait. *The Presentation of the Christ Child in the Temple,* painted by Giotto about 1320, is one of the first works visible to visitors as they enter the room from the stairwell, with the larger Sargent portrait coming into focus behind it. One of only a handful of works by this master in North

America, it is mentioned by Giorgio Vasari in his 1550 *Lives of the Most Excellent Painters, Sculptors, and Architects* as part of a series from Sansepolcro, in the Italian province of Arezzo. Small in scale but grand in impact, the work greatly rewards close inspection, as is suggested by Gardner's placement of it on a desk before a chair. At the center of the painting is a touching and intimate moment between a mother and child, as Christ, a vulnerable baby suspended over a ritual altar, reaches back to implore his mother for comfort. She remains eternally just out of his reach, however, separated from her human-yet-divine child by the architectural frame of the altar's canopy.

Set back to back against the Giotto, and in front of another chair, is Simone Martini's *Virgin and Child,* from about 1325. Like the work by Giotto, it shows the bond shared by the child and his doting mother, who leans over to him, in a tacit acknowledgment of his divine status. A small band of saintly figures appears in the lower register of the panel; on the far right side of this band is the diminutive figure of a female donor, clad in a nun's black habit. She is kneeling in prayer, asking viewers to remember her in prayer; at the same time, she is demonstrating her position as the person responsible for commissioning this painting. By placing her own portrait so close to this one, and in a corner of the room full of other divine figures, was Gardner somehow imitating the medieval donor, encouraging us to remember her admiringly and to keep her in our prayers?

The Gothic Room also holds a variety of sculpture, some devotional, some secular. One particularly fine German lindenwood image, *Saint Elizabeth of Hungary,* carved in Ravensburg in 1490, is positioned high on the west wall. The beautifully worked folds of her drapery give a luxurious feel to the otherwise austere beauty of this saint, who holds a loaf of bread for the poor. Another German work, the *Altar of the Holy Kinship,* carved in Saxony between 1510 and 1520, is much more playful and dramatic in appearance. Brightly colored and set against a background of tooled gold leaf, the figures are lively and quick. A sprightly toddler Jesus, arms akimbo, balances precariously between the laps of his mother, Mary, and his grandmother, Anne. Christ's followers, including young apostles, cavort along the lower edges of the altar, sometimes to almost comic effect. While one woman breastfeeds, a young child sits on the floor, happily drinking from what appears to be a beer stein. Also playful in tone is a carved antler chandelier (*Lüsterweibchen*), in the form of a woman, which is suspended from the ceiling near Saint Elizabeth. The ceiling itself is sculptural, with a rhythmic pattern of rough-hewn wooden beams running parallel from one end to the other; just below them, a friezelike series of sixty-eight portraits of Heroes of the Past, painted for a room in the Palazzo Vimercati in Crema, Italy, lines the upper limits of all four walls. In the southeast corner, the gilded image of the Archangel Gabriel perches high atop an orb. Said to be from a

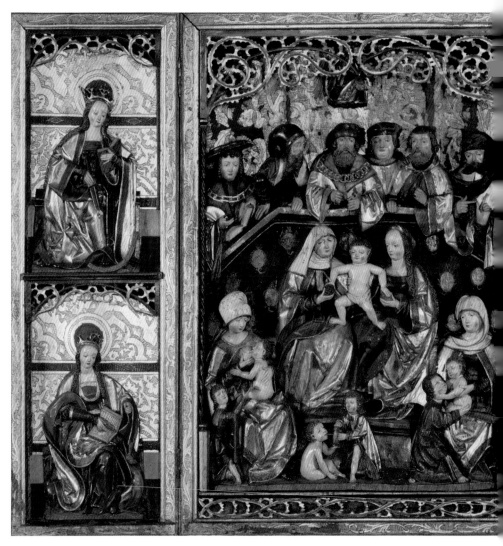

German, Saxony, *Altar of the Holy Kinship,* about 1510–20

church demolished by Napoleon, a historical figure of great interest to Gardner, this work was later struck by cannons during the Italian revolution of 1848. Perhaps intrigued by this tale, Gardner chose to display him with the gaping hole still clearly visible in his chest rather than having him restored.

The center of the room is dominated by two massive tables and assorted furnishings, both domestic and devotional in nature. One, a late nineteenth-century Venetian wood and marble table, is outfitted like an altar, complete with candlesticks and a Venetian gilded processional cross, from about 1450. The other, an early sixteenth-century walnut table, is covered with small decorative boxes, including a particularly luxurious wooden one from the Indian state of Gujarat, which is inlaid with intricate foliate designs in mother-of-pearl. Other

Persian, *Bull-Headed Mace,* 1785–86

boxes, fashioned from wood or metal, along with a book, a book box, metal locks, and a door knocker, complete the arrangement. As if any further proof of Gardner's far-reaching tastes were needed, she placed a Persian bull-headed mace from the late eighteenth century, made of cast iron and inlaid with silver and gold, at the north end of the table. According to tradition, it makes a distinctive whistling sound when swung.

Although it was closed to museum visitors during Gardner's liftetime, the Gothic Room was open to special guests, including Sargent, who used it as a studio in the winter of 1903. In fact, several portraits of prominent Bostonians were painted in this room, and they capture the ambience of the space as much as they capture the personalities of the sitters. One in particular, now in the

John Templeman Coolidge, John Singer Sargent painting Gretchen and Rachel Fiske Warren in the Gothic Room, 1903

collection of the Museum of Fine Arts, Boston, features a number of objects still on view in the Gothic Room. *Mrs. Fiske Warren (Gretchen Osgood) and Her Daughter Rachel* presents the pair sitting on an ornately carved seventeenth-century walnut and cherry chair from northeastern Italy. A friend of Isabella's and the daughter of a surgeon who worked with Louis Pasteur, Gretchen Warren was a highly educated woman who was offered academic positions at both Wellesley and Radcliffe Colleges, which she declined. Life imitates art here as she and her daughter mimic the close bond and cheek-to-cheek pose of the

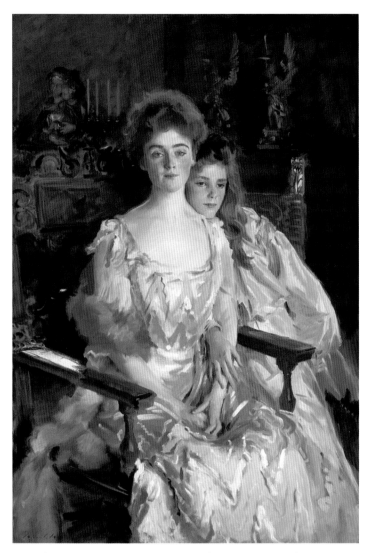

John Singer Sargent, *Mrs. Fiske Warren (Gretchen Osgood) and Her Daughter Rachel,* 1903. Museum of Fine Arts, Boston (64.693)

Italian *Virgin and Child,* a painted and gilded sculpture from about 1450, visible behind them. The portrait also features the seventeenth-century angel candlesticks installed in the Gothic Room. In many ways, this portrait perfectly sums up one of Gardner's greatest aims in assembling her collection and creating a museum at Fenway Court: she wanted to share beauty with those around her, thereby inspiring the creation of new works of art—both in her time and in that of generations to come.

Speak-a-bit

FOURTH FLOOR

The Gardner Museum was never intended to be a house museum in the traditional sense of the term. Rather, Isabella created it to be a stunning repository of important artworks from various places and times, all presented in an intimate environment that was meant to feel like a home. She did, however, use various public rooms and galleries for her own purposes from time to time. For example, she is known to have held dinner parties in the Tapestry Room and the Dutch Room, and the Macknight Room functioned as an office and sitting room during the last few years of her life. From its conception, however, a portion of the museum was intended to serve as her home, and the whole fourth floor was designed exclusively as her private residence.

The floor included quarters for her staff at the south end. A suite of spacious rooms wraps around the other three sides: a Dining Room with silver tea-papered walls and two luminous metal and glass andirons from Tiffany and Company in the fireplace; a Drawing Room, with a small waiting area outside it, the quaintly named "Speak-a-bit," where guests would wait before being escorted in to meet her; a wood-paneled Library; and finally a grand outdoor balcony on the east side. Through tall French windows that open to the Courtyard, many of which were decorated with nearly waist-high, intricately patterned wood screens from Japan, she could hear the Courtyard fountains and watch guests move through her museum on the floors below. From the large windows of the outer rooms, she could look out on the Muddy River and the developing neighborhood around her Palace on the Fenway.

Dining Room

Isabella brought marble fireplaces with carved wooden mantelpieces and also a number of floor-to-ceiling gold-framed Baroque mirrors from her former home on Beacon Street. Other touches from her time also remain intact on the fourth floor, including a series of tiles in the bathroom with witty French proverbs, including one that advises readers to "Pense moult, parle peu, ecris rien" (Think a lot, speak little, write nothing). Nods to these humorous touches can be found in the reproduction tiles in the walls of the public restrooms on the first floor. Otherwise, many of the other vestiges of Isabella's life on the fourth floor have vanished or been altered over time. She bequeathed most of her personal items, including clothing, jewelry, and household objects, to her favorite niece. After her death, three successive museum directors and their families lived in the residence, making changes to the space to suit their needs. Now the space is devoted to staff offices.

Window grates

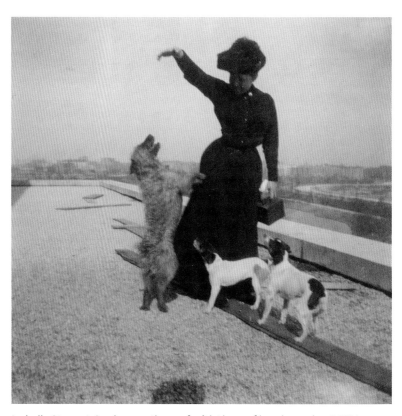

Isabella Stewart Gardner on the roof with three of her dogs, about 1901

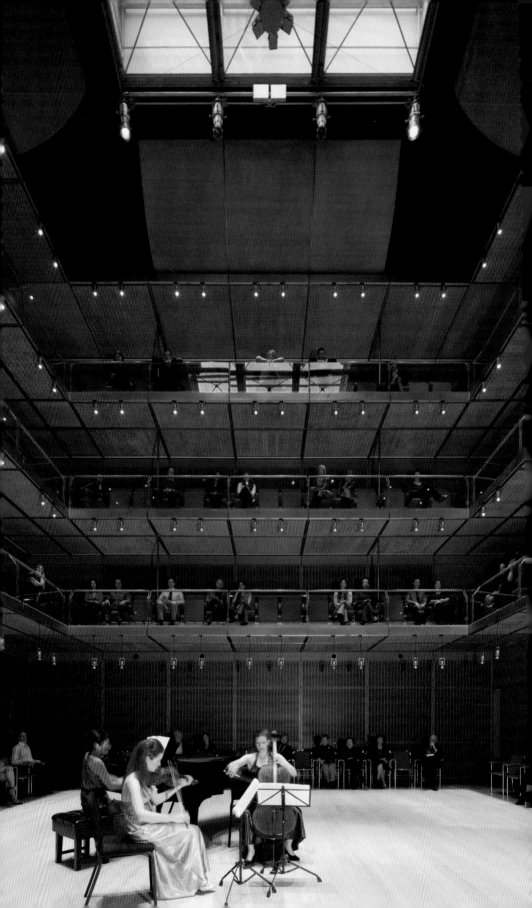

ISABELLA STEWART GARDNER'S LEGACY

As she made explicit in a letter written in 1917, near the end of her life, Isabella opened her museum to bring beauty to this "young country." She had spent the previous thirty years assembling an extraordinary collection and had installed it in inimitable fashion in an awe-inspiring setting—all in response to what she perceived as an intrinsic social need. In this regard, she followed the philosophy of influential nineteenth-century intellectuals who believed that art and beauty could ameliorate the ills of industrialized society, including the Harvard art history professor Charles Eliot Norton, whose classes she attended, and the English art critic John Ruskin, whose writing she admired. Yet, two decades into the twentieth century, she was looking forward as much as she was looking back. Her will echoes these sentiments, clearly stating that the museum was intended for the "education and enjoyment of the public forever"; in other words, the art of the past was intended to inspire the art of the future. From the opening of the museum in 1903 until her death in 1924, she welcomed some of the most creative painters, performers, scholars, and writers of her time. It is to this legacy that the museum pays tribute today. Its many programs give audiences access to the beauty of the historical collection and also introduce them to new works of art and new ideas. The museum's recently constructed wing, opened to the public in 2012, plays a critical role in this.

Calderwood Hall

Designed by the Renzo Piano Building Workshop, the wing serves two mission-critical purposes. First, it preserves Gardner's spectacular collection and singular curatorial vision by moving visitor amenities—the coat check, the restaurant, the shop, and, most importantly, the museum's growing programming—out of the historic building. This limits the stress on the historic building and allows the museum to continue to welcome a growing number of visitors year after year, as it has for decades. It also allowed for the creation of spacious, state-of-the-art conservation facilities. Second, and equally important, it gives greater access to the collection and to Gardner's extraordinary vision through new orientation, exhibition, and performance spaces. The transparent glass-and-steel first floor positions the museum as an integral part of the neighborhood, inviting visitors in to take a closer look. While the historic building is relatively dark and atmospheric, with the central Courtyard drawing the eye inward, the light-filled addition provides views out to the neighborhood and city. At the same time, the New Wing pays homage to Gardner's Venetian-style palace by subtly incorporating materials found in the historic building, including red brick, bluestone pavement tiles, and copper cladding, but translating them into a completely contemporary aesthetic. The two buildings underscore the Gardner Museum's dedication to both historic and contemporary art, and to sparking a dialogue between them.

CONTEMPORARY ART

The appearance of the New Wing, with its openness and transparency, announces the museum's commitment to the art of our time and to welcoming new audiences. In fact, before visitors even come through the front entrance they experience a work of contemporary art on its façade, in the shape of a large banner. The museum's Anne H. Fitzpatrick Façade, which measures thirty-six by sixteen feet, presents a new site-specific artwork at six-month intervals. Commissioned to enliven the urban landscape, this public art shares a thought-provoking experience with the city.

The façade artwork is a product of the museum's multidisciplinary artist-in-residence program. Since 1992 close to one hundred artists, both emerging and established, have enjoyed the gift of time with the collection and its archive. Isabella had invited artists to live and work at her museum, famously allowing John Singer Sargent to use the Gothic Room as his studio when he painted the portraits of prominent Bostonians. Lesser-known artists such as Dodge Macknight, for whom one of the galleries is named, also spent time at the museum. Just as Gardner felt that contemporary artists could learn from the old masters she collected, contemporary artists can help current audiences see her collection with fresh eyes. For this reason, the museum invites a number of artists to live, think, and work at the museum each year, usually for a month, in

The Anne H. Fitzpatrick Façade with Maurizio Cannavacciuolo's *A Lecture on Martian History*, 2016

two apartments above the greenhouse in the New Wing. Gardner Museum artists in residence have come from around the world—Africa, Asia, Europe, and North and South America. Residents are not just visual artists but also writers, poets, scholars, musicians, landscape designers, and even a chef.

HORTICULTURE AND LANDSCAPE

As visitors enter the museum, an important aspect of Gardner's legacy becomes immediately apparent: her love of gardening and her belief that the cultivated natural world was an important component of civic life. Isabella maintained a series of English, Italian, and Japanese gardens on the grounds of her estate in Brookline. She also was known for displaying an array of blooming plants in a large bay window in her townhouse on Beacon Street in Boston. Newspapers from her time recounted stories of the crowds that flocked to see her spring flowers. Wanting to share this passion with others, and believing that the beauty of gardens, no matter the size, could brighten city life, she also initiated a window box contest in working-class neighborhoods of Boston and encouraged all ages to apply. She visited the finalists personally and held an award ceremony at her Brookline house.

Monk's Garden

Today, visitors to the museum are greeted by a magnificent, colorful display of flowers and plants near the main entrance. While some of these plants will be rotated into the Courtyard display, others, like the night-blooming cereus, appear here simply because Isabella grew them in her greenhouses. Visitors may stroll through the greenhouses to get a closer look at the plants or to smell the leaves of the scented geraniums and other fragrant specimens.

The grounds of the new and historic buildings also feature gardens, including the Monk's Garden and the Darlene and Jerry Jordan Garden. The Monk's Garden, where Isabella used to walk her beloved dogs, has taken a variety of forms over the years. In 2013 the garden was completely redesigned by Michael Van Valkenburgh Associates, offering a contemporary landscape response to the museum's meandering galleries and the rich colors and textures of its idiosyncratic collection. Seating in the Monk's Garden invites visitors to stop and reflect on the visual richness of both garden and gallery spaces. A number of the museum's annual programs, including lectures, offer significant opportunity for audiences to consider the ways landscape architects are reinventing and redefining outdoor spaces today.

MUSEUM EDUCATION AND COMMUNITY ENGAGEMENT

Other public spaces in the new wing echo Isabella's gracious hospitality, her support of education, and her love of books. Most conspicuously, bookshelves run from floor to ceiling across the main corridor. These books are related to the museum's collection and the different art forms presented in its programs, including historic and contemporary art, horticulture and landscape, music, and museum education. Visitors may take volumes that interest them to the nearby Living Room.

Inspired by an installation piece created in 1999 by artist in residence Lee Ming Wei, the Living Room is the perfect place to begin or to end a visit to the Gardner. In keeping with the intimate, houselike setting of the historic museum, the Living Room was designed to help visitors feel at home by offering comfortable seating, books, and electronic resources. Visitors can learn about the Gardner Museum, explore their own questions about art, or simply relax while contemplating the gardens.

Visitors can also learn more about the museum, its collection, its history, and its current programs through guided and self-guided tours, artist's talks, and lecture series. Hands-on workshops take place weekly in the Bertucci Education Studio; these include opportunities to meet local artists and to create art with them. Artworks by visitors and Boston students are regularly exhibited on the Linda Cabot and Ed Anderson Student Art Wall outside the studio, which was modeled on the project board that the Renzo Piano Building Workshop uses in its architectural offices. Community programs, summer Neighborhood Nights, several annual free days, and school vacation programs all demonstrate

Living Room

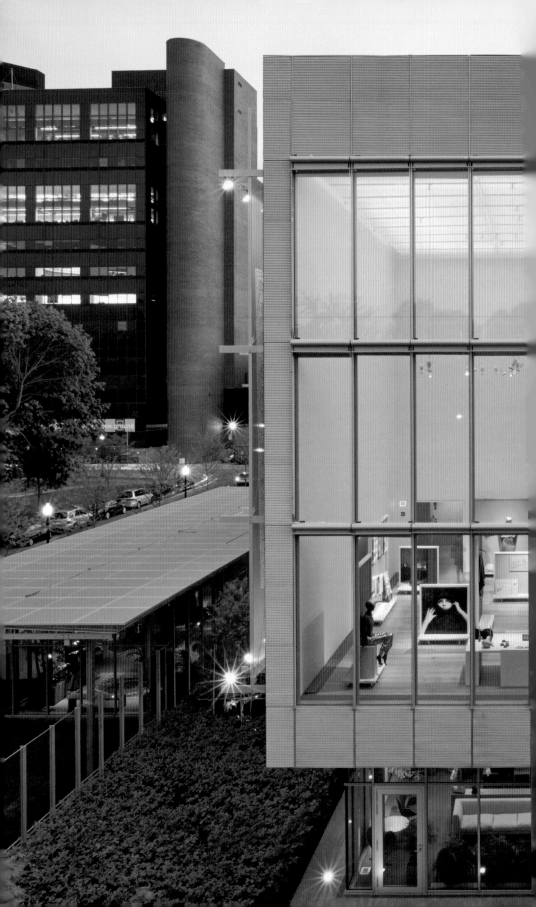

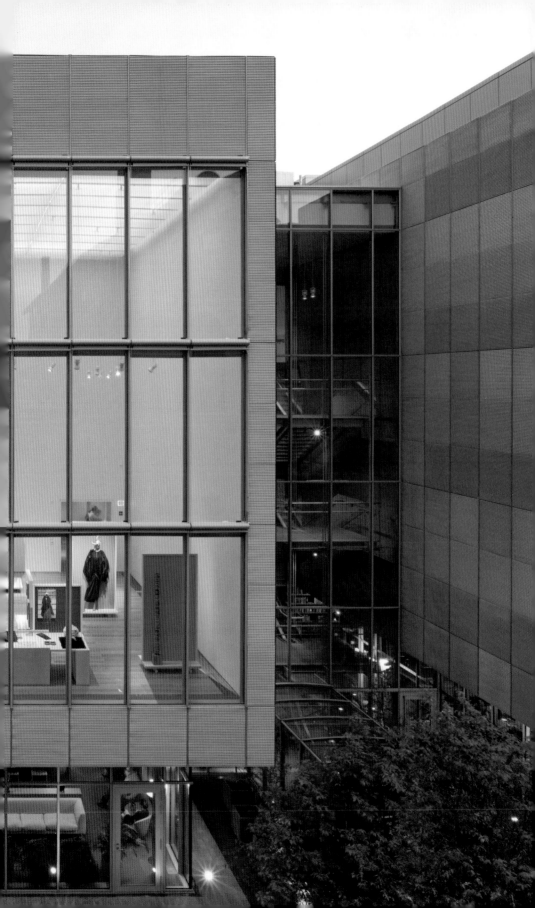

Bertucci Education Studio

the Gardner's commitment to being a local resource and inspiration for Boston and the region.

EXHIBITIONS AND PUBLIC PROGRAMS

Two striking spaces, one for exhibitions and the other for public programs, are located on the second floor of the new wing: Calderwood Hall and Hostetter Gallery. Conceived by Renzo Piano as two identical architectural cubes, they appear from the outside to be floating above the transparent first floor. Calderwood Hall, in particular, recalls the Palace: the soaring space reaches up four floors and appears to be open to the sky by virtue of a glass roof—just like the Courtyard.

Begun in 1927, the Gardner Museum is home to the longest-running museum music program in the nation and presents many acclaimed performances each year, with genres ranging from classical to jazz to hip hop. The Gardner has helped provide recognition for many emerging artists, and Calderwood Hall is proving to be an inspiration for all who perform there. Designed with the help of the world-renowned acoustician Yasuhisa Toyota, this one-of-kind performance hall holds almost three hundred people.

On the main floor, the audience is arranged on all four sides of the performers, and on each of the three balconies there is only one row of seating—effectively giving everyone a front-row seat. Because there is no raised stage, and because the audience surrounds the performers, the space between the two is seemingly erased—providing an intimate experience for both performers and audience. In addition to concerts, a variety of other public programs take place in Calderwood,

Previous pages: Hostetter Gallery

including regular introductions to the museum, lectures and panels featuring scholars and contemporary artists, and dance or theatrical performances.

Like Calderwood Hall, the special exhibition space is also a cube, but a cube with very flexible proportions and lighting conditions. The ceiling can be adjusted to three different heights, allowing for the presentation of everything from small-scale Renaissance panel paintings to monumental contemporary sculpture. Similarly, the wall of windows on the north side can permit unobstructed views of the historic building and the Monk's Garden. Alternatively, they can be partially screened to allow for soft, filtered light, or they can be completely covered for blackout conditions, depending on the type of artworks being shown and their sensitivity to light. Over the course of any given year, Hostetter Gallery will be filled with exhibitions featuring historic or contemporary art. The exhibitions featuring historic art take as their point of departure a work in the collection, shedding new light on it and on its place in the museum. The programming around the historic shows also helps to place works in a broader historical context, while at the same time helping visitors understand the current relevance of the universal human themes suggested by these works, creating a bridge between the past and the present. In this way the historic works come to life for audiences. Likewise, the contemporary exhibitions make explicit the connection between programs of today's art and Isabella's advocacy for the art of her time, and they usually feature the work of former artists in residence.

ARCHIVES AND CONSERVATION

The third and fourth floors of the new wing primarily serve the administrative needs of the museum. While access to these floors is limited, the mission-critical work of two of the departments housed here—Archives and Conservation—has been made more accessible to the public. For example, the archival Reading Room on the third floor is an important research center for members of the museum staff and for the artists and scholars in residence; it is also open by appointment to qualified outside scholars. In the Reading Room, researchers have access to Gardner's personal papers and journals, her copious correspondence, and other fascinating memorabilia relating to the formation of the collection that Isabella once displayed in cases in her galleries. To preserve these items for future generations, the museum now keeps the bulk of them in storage, in accordance with best practices. However, ongoing digitization and photography efforts will make these rich resources increasingly available to interested persons, both on site and online.

The task of preserving Isabella's vision in perpetuity has occupied the museum's conservators for nearly a century—and it is work that will, in fact, never be completed. Beginning in the 1930s the Gardner Museum, along with

other Boston area museums, conducted groundbreaking conservation research, laying the foundation for the emerging field of modern art conservation. Foremost among the Gardner's early conservators was George L. Stout, a pioneer in the field who engineered innovative approaches to the treatment of works degraded by time. As director of the Gardner from 1955 to 1970, Stout strengthened the museum's commitment to preservation, a legacy that lasts to the present day. In the Poorvu Family Conservation Center, which occupies most of the fourth floor of the New Wing, staff members treat a range of works, including paintings, objects, and textiles.

While it is true that the museum's collection is still arranged as Isabella left it—that the works in the galleries and the installations of objects are permanently "fixed"—the institution as a whole is far from static. The museum's dedicated conservators work to find ways to preserve the galleries; curators present ideas about art and artists past and present; educators create ways for the public to interact with the collection; and musical offerings, as essential in Isabella's time as they are today, change to attract new audiences. Above all, the Gardner Museum is a place where visitors of all ages can make deep personal connections to the art of the past and present. Isabella kept open the question of what her museum meant during her own lifetime, and we continue to see its meaning evolve as we think of new ways to deepen connections with new audiences and different communities. Just as she saw her life's work as the fulfillment of a desire to fill a social need—the need for "beauty" that would educate, bring enjoyment, and inspire new works of art and ideas—so too does the Isabella Stewart Gardner Museum seek new ways to play a vital role in the cultural fabric of the city of Boston, and far beyond.

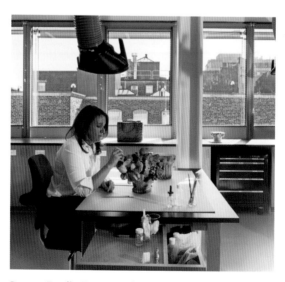

Poorvu Family Conservation Center

INDEX

PHOTOGRAPHIC CREDITS

This guidebook is generously funded by
Rick and Sadhana Downs.

Type composed in
Dutch Type Library Elzevir
and Mallory

Isabella Stewart Gardner Museum: A Guide succeeds *The Isabella Stewart Gardner Museum: A Companion Guide and History,* published 1995 by Yale University Press.

yalebooks.com/art

Designed by Miko McGinty and Rita Jules
Set in type by Tina Henderson
Printed in China through Oceanic Graphic International, Inc.

Library of Congress Control Number: 2017939207

ISBN 978-0-300-22647-8

A catalogue record for this book is available from the British Library.

This paper meets the requirements of ANSI/NISO Z39.48-1992 (Permanence of Paper).

10 9 8 7 6 5 4 3 2 1

Page vi: Calderwood Hall